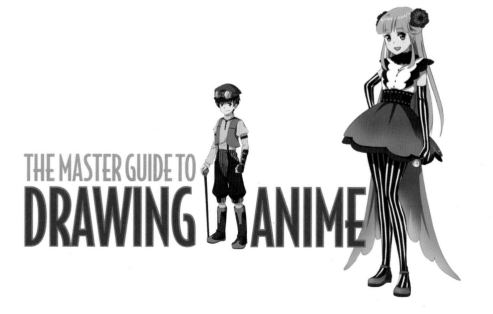

THE MASTER GUIDE TO
DRAWING ANIME

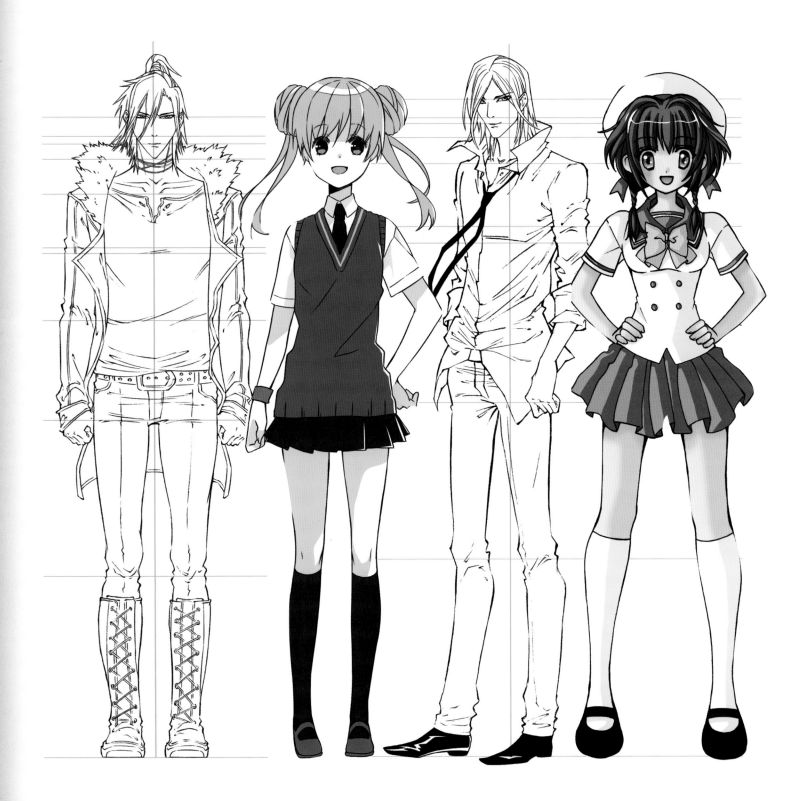

DRAWING WITH *Christopher Hart*

THE MASTER GUIDE TO DRAWING ANIME

How to Draw Original Characters from Simple Templates

sixth&spring
books
NEW YORK

DRAWING WITH Christopher Hart

An imprint of Sixth&Spring Books
104 West 27th Street, New York, NY 10001
sixthandspringbooks.com

Managing Editor
LAURA COOKE

Art Director
DIANE LAMPHRON

Senior Editor
LISA SILVERMAN

Editor
ALISA GARRISON
LAURA COOKE

Editorial Assistant
SARAH THIENEMAN

Contributing Artists
ANZU
ERO-PINKU
INMA R.
TINA FRANCISCO
TABBY KINK
AYAME SHIROI

Vice President
TRISHA MALCOLM

Publisher
CAROLINE KILMER

Production Manager
DAVID JOINNIDES

President
ART JOINNIDES

Chairman
JAY STEIN

Library of Congress Cataloging-in-Publication Data
The master guide to drawing anime : how to draw original characters from simple templates / Christopher Hart. — First Edition.
 pages cm
 ISBN 978-1-936096-86-2
 1. Comic books, strips, etc.—Japan—Technique.
2. Cartooning—Technique. 3. Comic strip characters. I. Title.
 NC1764.5.J3H36945 2015
 741.5′1—dc23

 2014030200

MANUFACTURED IN CHINA

9 10

First Edition

Dedicated to you and to anime fans everywhere!
— CHRISTOPHER HART

www.christopherhartbooks.com

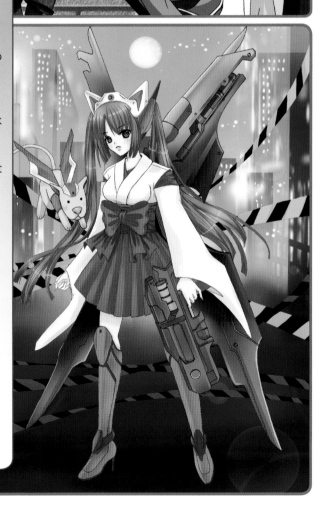

Author Note

This practical guide will not only show you how to create original characters but also help you to build a rock-solid foundation as you go forward with your artwork. Keep this book handy, and turn to it whenever you need some inspiration. I want to express my thanks for the opportunity to share in your progress. I hope you'll check out some of my other popular titles on manga, figure drawing, and cartooning. And feel free to stop and say hello or ask me a question on social media. Until next time, always remember, you deserve to succeed!

www.facebook.com/CARTOONS.MANGA

— *Christopher*

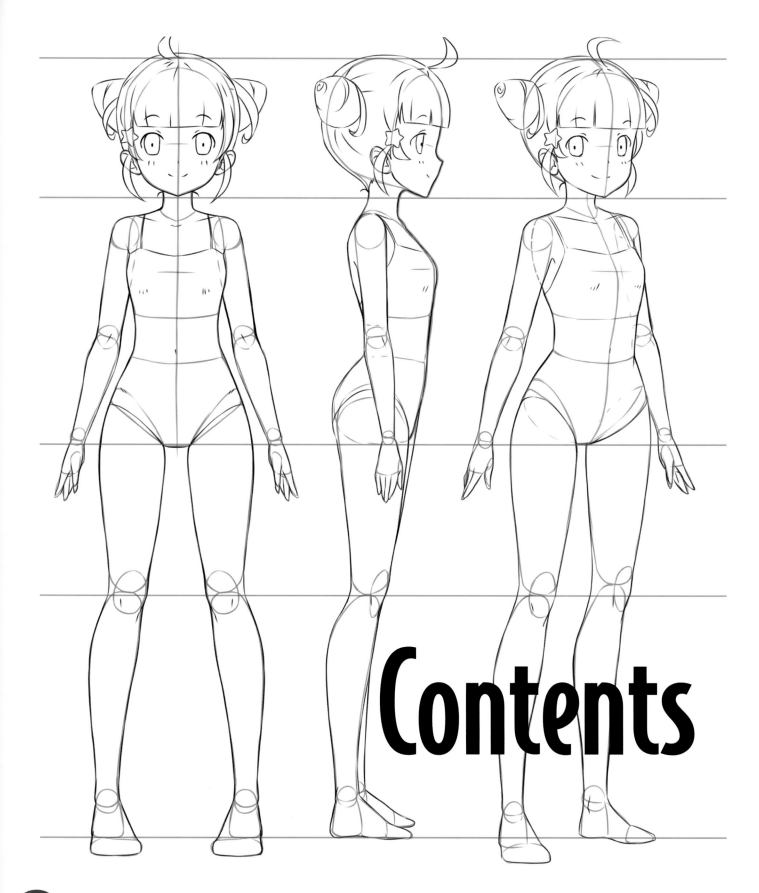

Contents

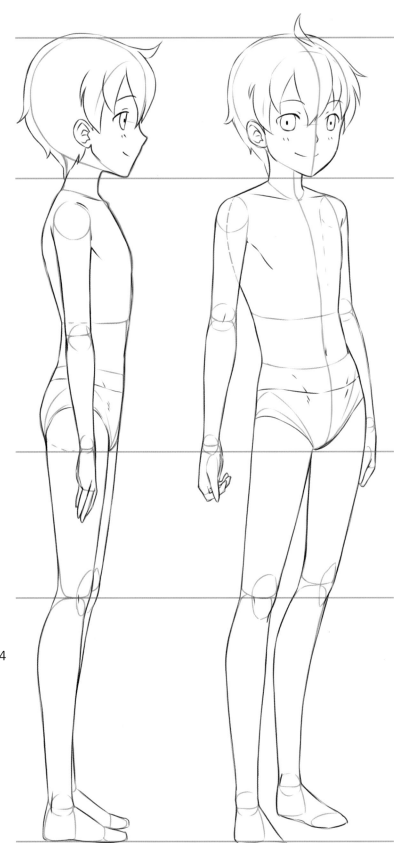

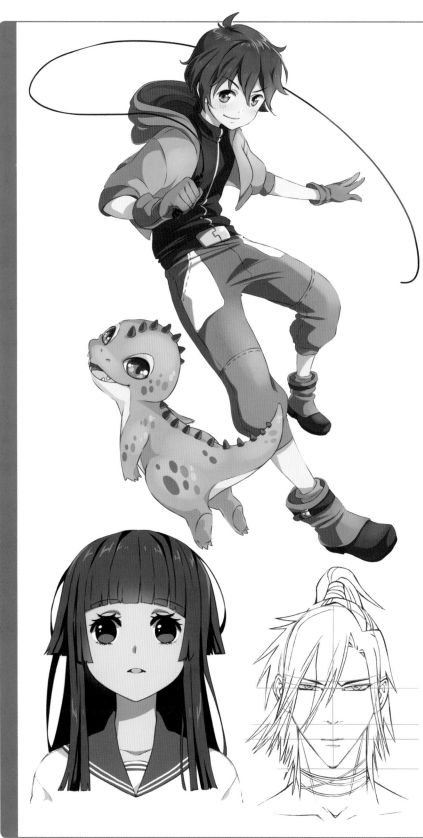

Introduction

Finally—the ultimate drawing guide for the anime artist!

This book focuses on the leading character types of anime based on the most popular genres. And best of all, it gives you templates you can use to draw a limitless number of variations on those characters.

What is a template? A template is a basic form that you can customize to create an original character. Anime artists in Japan rely on templates for their characters that show the various angles of the head and body, the proportions, and a selection of outfits. This is also called a "model chart."

This book uses a similar principle. Each chapter begins with a basic template, such as a traditional schoolgirl character. Then I'll show you, step by step, how to add little changes to the eyes, hair, pose, costume, and color to end up with a completely original character.

You'll never have to struggle to draw a character again. Why start from scratch, when you can begin with the templates in this book? For many aspiring artists, as well as seasoned professionals, inventing original characters is the best part of drawing anime. Let's get started now. Drawing original characters has never been so easy to do! ■

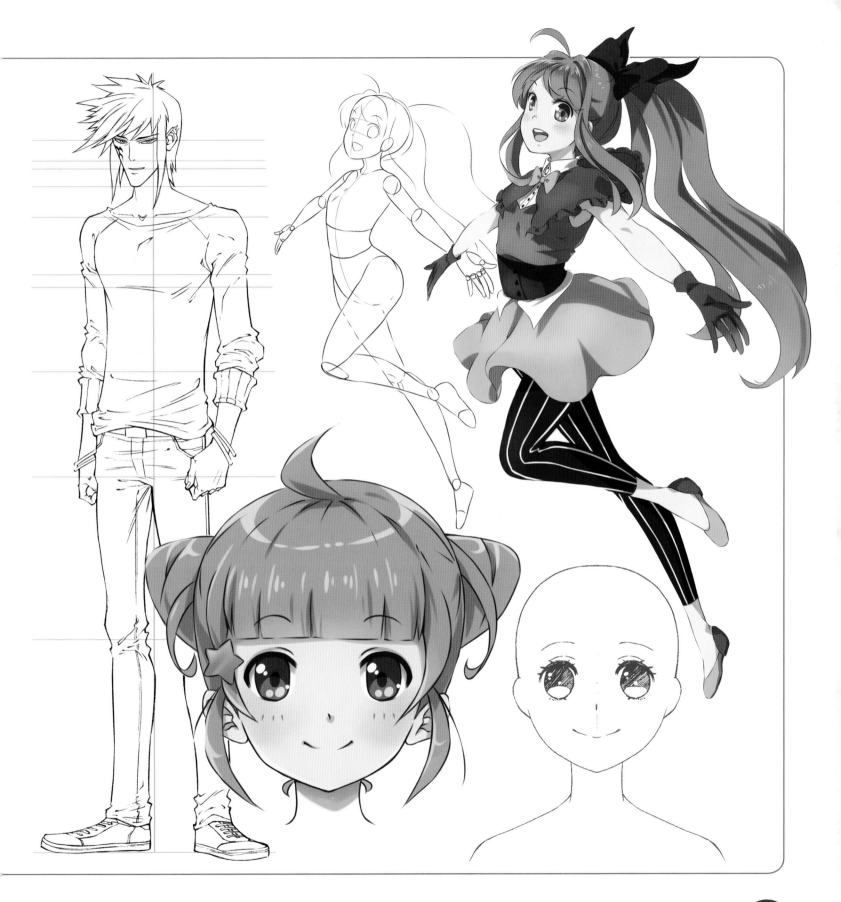

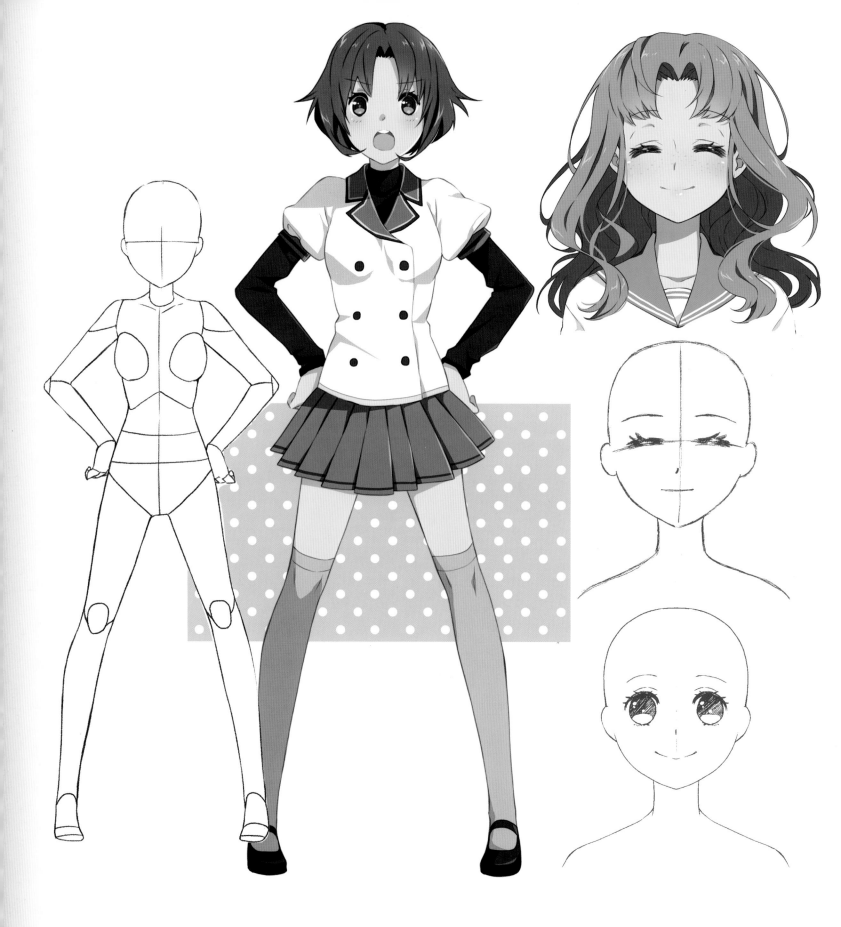

Schoolgirls

School life is a popular genre which features trademark school uniforms and engaging high school characters.

Schoolgirl types have a range of personalities, such as the amiable klutz, the hopeless romantic, and the wallflower. Often, characters share the same basic head and body shape; therefore, you can use the standard schoolgirl model, provided in this chapter, as the foundation for each one. In other words, if you can draw one type, you can draw them all.

The characters are approximately 13 to 17 years old with large and expressive eyes and well-coordinated outfits. In addition, the hairstyle is an important feature of each character.

Once you've got the basics down, the next step is the key: creating original characters by combining features from a menu of possibilities for eyes, hair, outfits, accessories, facial expressions, and poses. ■

Head Proportions 360° Template

No doubt you've run into this problem before: you've drawn a character, but you can't make it look the same when you draw it at another angle. The key lies in maintaining the character's basic underlying proportions. The following templates are based on average proportions. You can adjust them according to your taste.

• The head is as long (from top to bottom) as it is wide (from side to side).

• The eyes are placed lower on the face than on a realistically

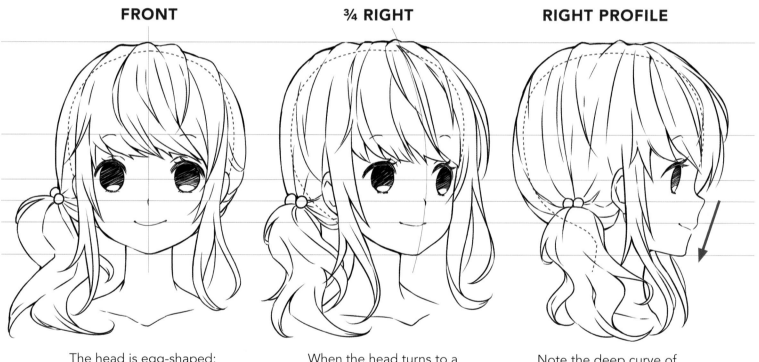

FRONT	**¾ RIGHT**	**RIGHT PROFILE**
The head is egg-shaped: wider on top and narrower at bottom, with a delicate chin and thin neck.	When the head turns to a ¾ view, the far side of the face and the features are compressed, therefore, the far eye appears slender.	Note the deep curve of the bridge of the nose and the inward angle of the mouth/chin area.

drawn person. (They're normally halfway down the head.)

Draw the eyes two-thirds of the way down the face.

• The eyes are also spaced somewhat farther apart here than they would appear on a real person.

• The ears are drawn between the eyes and the nose.

(On a real person, they're higher.)

• The neck is thin, which makes the head look wider by contrast.

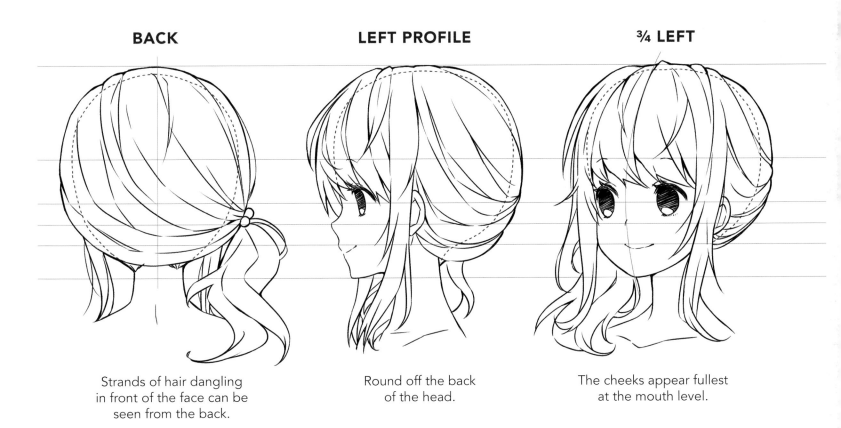

BACK

Strands of hair dangling in front of the face can be seen from the back.

LEFT PROFILE

Round off the back of the head.

¾ LEFT

The cheeks appear fullest at the mouth level.

Templates for Eye Color

Every anime artist knows that the eyes are the most "stand out" feature of the face. Therefore, it's essential to individualize them in order to create an original character. Think about which eye color you envision for your character. Let's take a look at some popular options and techniques.

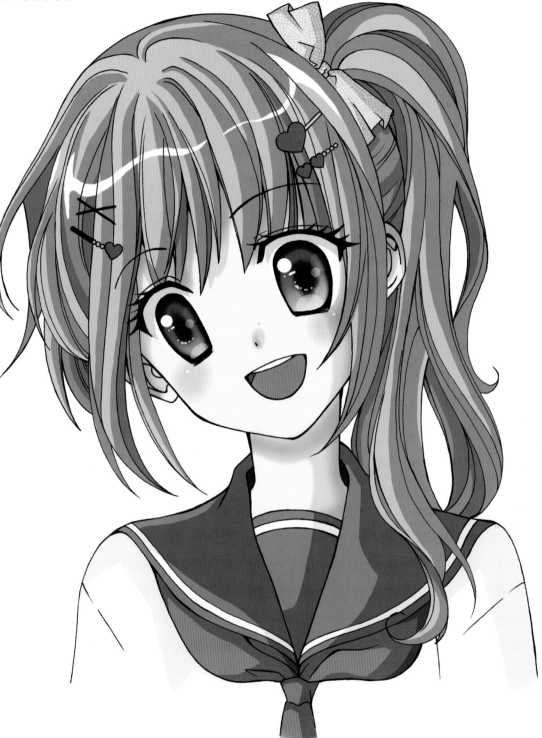

BLUE-BLACK

The large black pupils meld with the black shadow that falls on the upper eyeball. The bottom has blue fill.

GREEN

The darker green indicates shadow on the top half of the eyes.

BROWN

A thick outline surrounds the eyeballs; the pupils are tiny.

A Word about Using Color

Selecting different color eyes for different characters makes it easier to create different identities when you have multiple characters in a scene.

Creating Variations Based on the Template

It's hard to create original characters from scratch. But by using the templates in this book, you can create a limitless number of characters from the same basic head shape.

The following three elements are most useful for creating a variety of different characters from a single head shape:
- Hairstyle (Varying the hairstyle is very important for creating different characters.)
- Coloring (eyes, hair, and outfit)
- Personality type (expression)

■ **TYPE:**
CHEERFUL GIRL
(LEAD CHARACTER TYPE)
■ **HAIRSTYLE:**
PIGTAILS

This is an essential character type. Note her hairstyle. Pigtails and ribbons give this character a bubbly charm. The short strands in front of her ears are the signature look of many schoolgirl characters. In the fantasy genre, these strands often become gigantic with dramatic swirls.

BASIC HEAD TEMPLATE
Each character in this section starts with this basic head shape. Notice how variations in hairstyle, coloring, and expression individualize them.

BASIC EYES TEMPLATE
Eyes are bold and round with thick eyelashes.

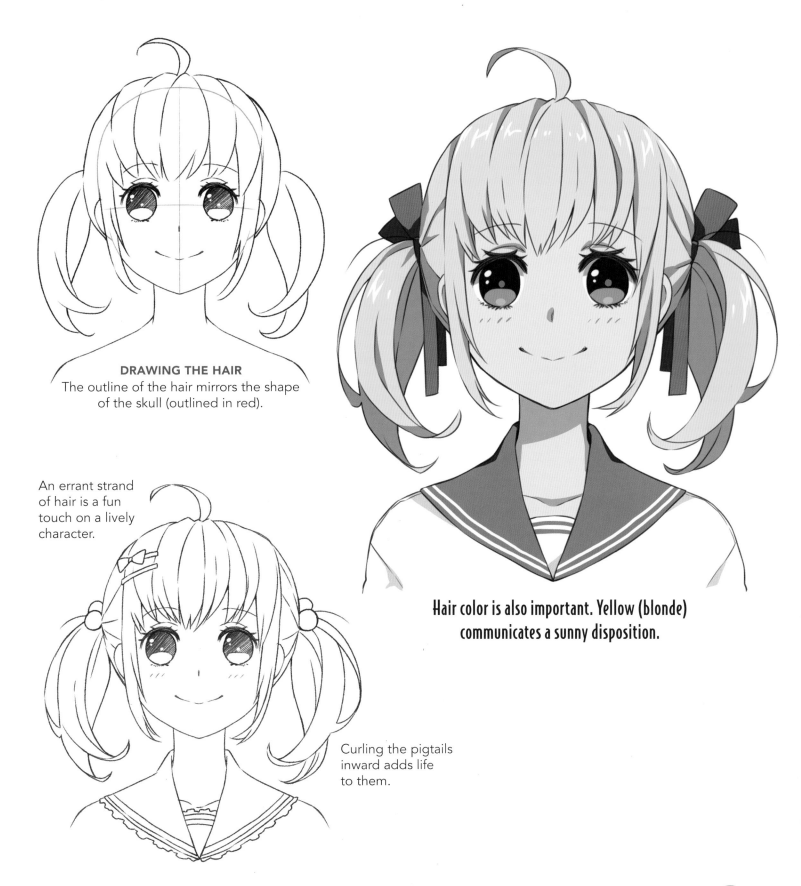

DRAWING THE HAIR
The outline of the hair mirrors the shape of the skull (outlined in red).

An errant strand of hair is a fun touch on a lively character.

Hair color is also important. Yellow (blonde) communicates a sunny disposition.

Curling the pigtails inward adds life to them.

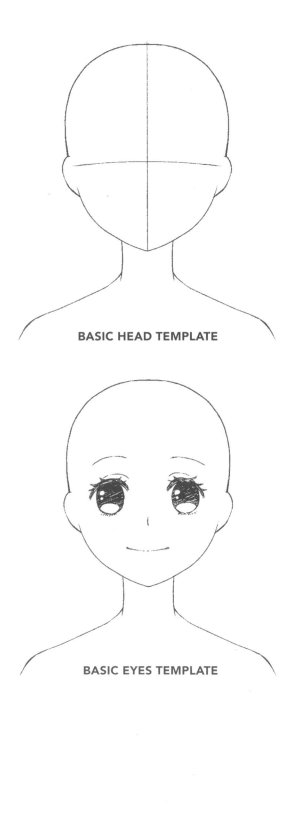

BASIC HEAD TEMPLATE

BASIC EYES TEMPLATE

■ TYPE:
THE BEST FRIEND
■ HAIRSTYLE:
LONG BOB WITH BANGS

We start with the same basic head construction as we did on the previous pages. With a simple hairstyle and color change, this character looks very different. The best friend is an important character. The conversations (dialogue) between the lead character and her best friend are used to move the story forward.

The best friend is mildly pretty, but should not outshine the star character's good looks! The best friend's hair is relaxed and casual. This hair is brown with sand-colored highlights zigzagging through it. Brown hair will appear muted next to the lead character's blonde hair.

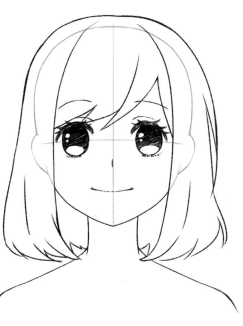

Now we're going to veer from the basic template. At this point, we reinvent the hairstyle. The hair is just a touch on the droopy side, which will give her an honest and unassuming look.

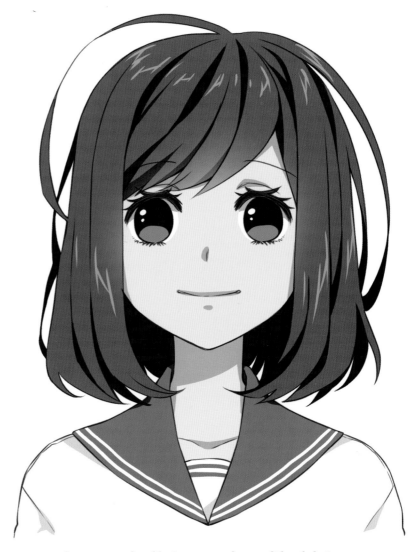

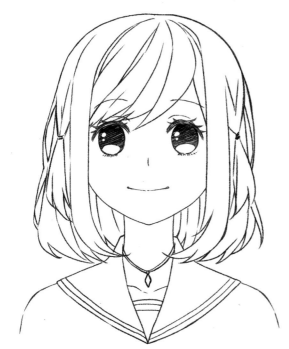

Some strands of hair seem to have a life of their own.
This makes the hair look natural and adds energy to the style.

Layer the hair to give it depth.
Hair hangs over the ears.

■ TYPE: SILLY & CLUMSY
■ HAIRSTYLE: WAVY

Comedy finds its way into practically every schoolgirl story. And the silly, good-natured klutz is a great character for comic relief. She needs a hairstyle that reflects her personality—something that doesn't take itself too seriously, like the character herself. Wavy hair is a lively choice. As for color, we want something a little offbeat, which is why orange works well.

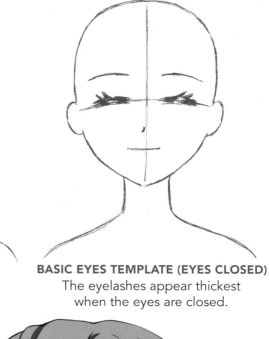

BASIC HEAD TEMPLATE

BASIC EYES TEMPLATE (EYES CLOSED)
The eyelashes appear thickest when the eyes are closed.

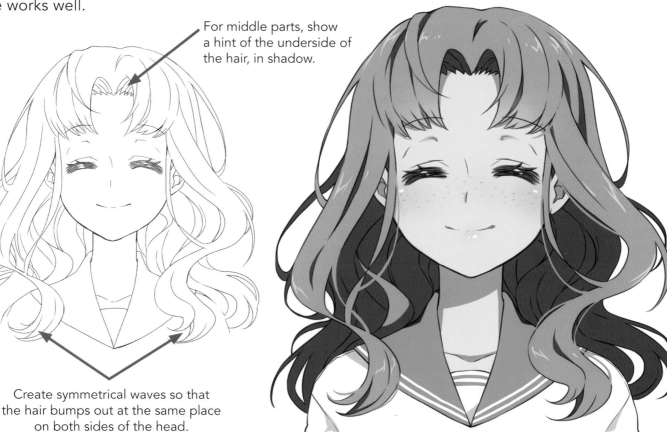

For middle parts, show a hint of the underside of the hair, in shadow.

Give her hair a carefree look.

Create symmetrical waves so that the hair bumps out at the same place on both sides of the head.

Freckles and blush finish the look. Note the shaded interior of hair.

■ TYPE: SHY GIRL
■ HAIRSTYLE: PRINCESS CUT

The little secret among professional writers is that audiences love to feel sad. Characters that pull at our heartstrings pull us into the story. The shy girl is a somewhat withdrawn, and a sympathetic, character. The traditional Japanese name for this haircut is hime (literally "princess cut"). It's a blunt multilayered cut that was worn by nobility in ancient times—and in today's popular anime.

BASIC HEAD TEMPLATE

BASIC EYES TEMPLATE
Subdued expression

Bangs drawn on a curved line.

Side bangs

Front strands

Long in back

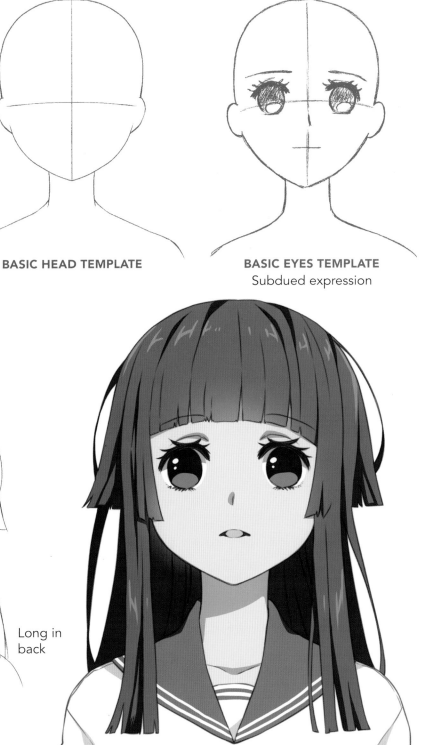

Gray eyes are an unusual color pick, but when tied into the gray hair color, it works as a theme to make her appear low key and wistful.

More Variations

These schoolgirl types are based on the exact same head types and expressions as before. And yet, because of the difference in hairstyles and accessories, each has a distinct look. This demonstrates the power of mixing and matching different components when creating your own original characters.

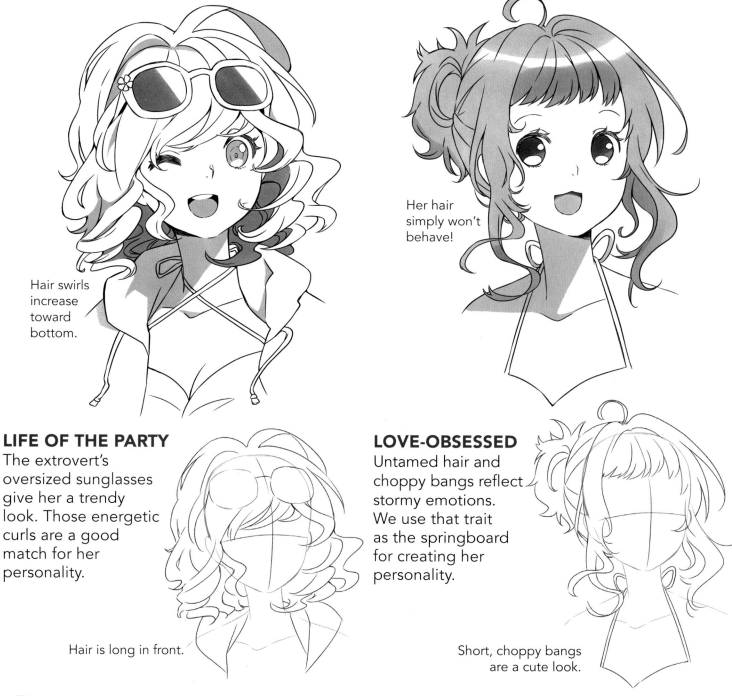

Hair swirls increase toward bottom.

Her hair simply won't behave!

LIFE OF THE PARTY
The extrovert's oversized sunglasses give her a trendy look. Those energetic curls are a good match for her personality.

Hair is long in front.

LOVE-OBSESSED
Untamed hair and choppy bangs reflect stormy emotions. We use that trait as the springboard for creating her personality.

Short, choppy bangs are a cute look.

These two "loner" types share the same head shape: sleek and slightly elongated (less round). However, because the hair, eyes, expression, and hint of an outfit are different, each becomes a unique character.

Heavily shaded upper eyeballs add a glamorous and wistful look.

Glasses are stereotypical for "brainy" characters.

BOOK WORM LONER

The "loner" type is an important cast member in the school-life genre. Everyone can relate to feeling like an outsider at some point.

The middle part creates a neat and symmetrical look.

MYSTERY GIRL LONER

The mysterious loner is beautiful but dreamy. It's as if we're seeing her through a window.

Hair lays flat on her head until ear level, at which point it opens up with waves.

23

Schoolgirl Body Proportions

This standard body works for most schoolgirl types. To create individualized characters, you can draw the figure fuller or with somewhat longer legs, and so on; however, making too many changes to the basic type can lead you down the rabbit hole, where you ultimately lose the integrity of the character. Making minor changes avoids this problem. And that brings us to the subject of character height.

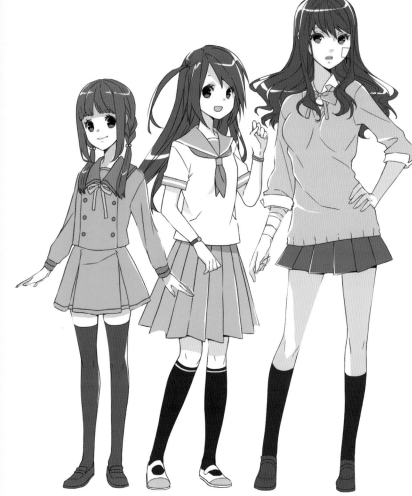

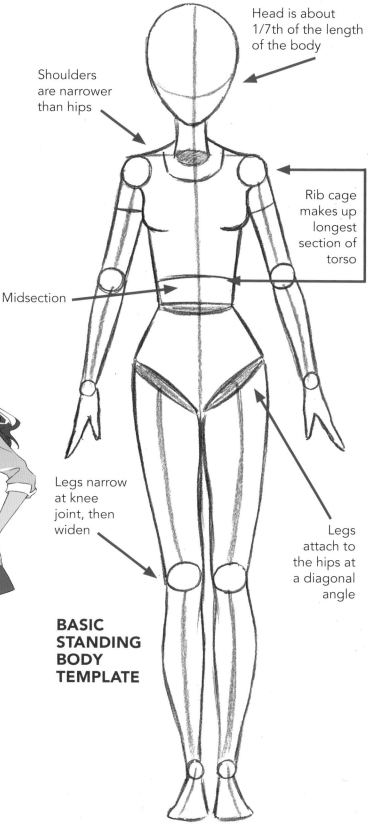

Head is about 1/7th of the length of the body

Shoulders are narrower than hips

Rib cage makes up longest section of torso

Midsection

Legs narrow at knee joint, then widen

Legs attach to the hips at a diagonal angle

BASIC STANDING BODY TEMPLATE

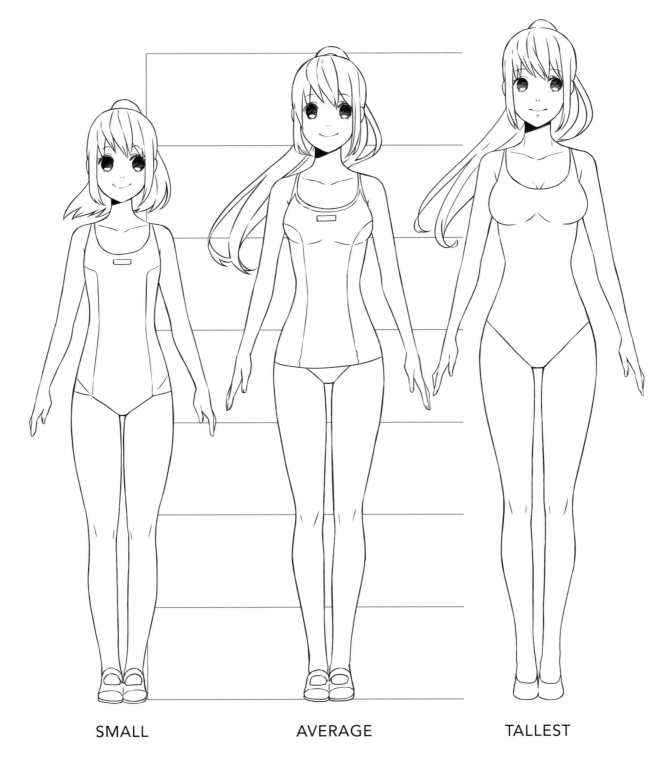

SMALL AVERAGE TALLEST

CHARACTER & HEIGHT TEMPLATE

Nothing defines characters in a cast as effectively as varying their heights. The viewer instinctively notes, "That's the tall one, that's the short one, and that one's average height"—and then begins to associate the character with its relative height in the group. Notice that the heights don't need to vary much in order to create a distinction between the characters. The length difference of a quarter to a half of a head length is plenty.

Basic 360° Schoolgirl Body Template

The red guidelines are drawn across the figures to maintain the body proportions of the character at all angles. It's good to practice these yourself. These "measuring points" are located at the following spots:

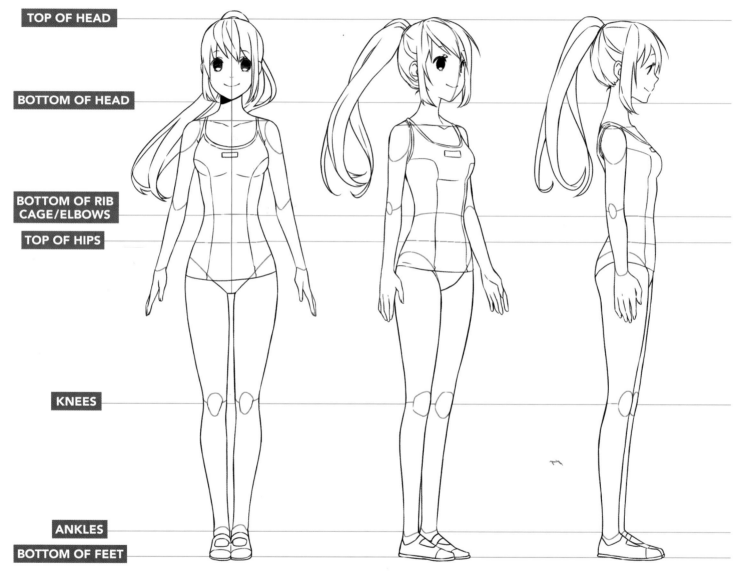

TOP OF HEAD

BOTTOM OF HEAD

BOTTOM OF RIB CAGE/ELBOWS

TOP OF HIPS

KNEES

ANKLES
BOTTOM OF FEET

FRONT
Excellent angle for establishing a character, for funny reaction shots, and for close-ups.

¾ RIGHT
This angle works with everything, especially forced perspective. Good for gestures, and fashionable and sitting poses.

RIGHT SIDE
An effective angle for confrontations, this pose can become tiresome if used too frequently.

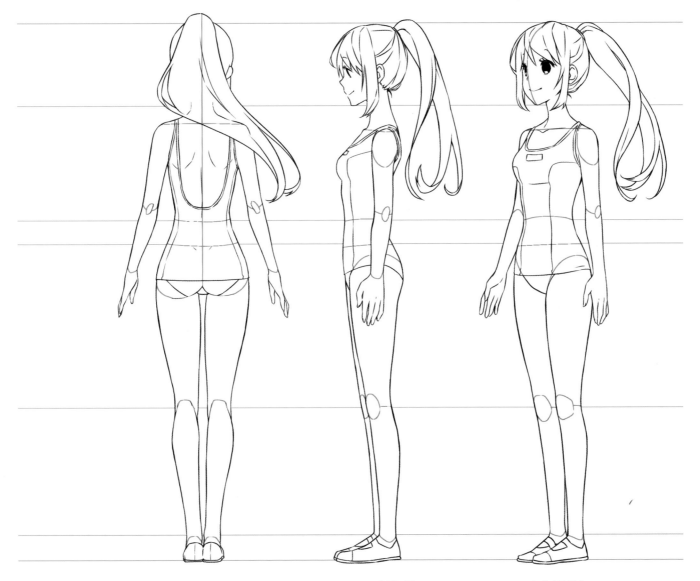

BACK
Infrequently used.

LEFT SIDE
Same as the right-facing side pose.

¾ LEFT
Same as the ¾ right pose.

Fashions & Outfits

The next stage in the development of an original character is the outfit. Since the bodies are based on the same template, the clothing is what differentiates one character from another. In other words, your choice of fashions becomes part of the character design. Let's explore some clothing ideas that help to create original character types.

USING VARIETY
Many outfits are created from a variety of elements that match well with one another. If they match too closely, there's no contrast. If they are too dissimilar, they won't go well with each other. Strike a balance between the two approaches.

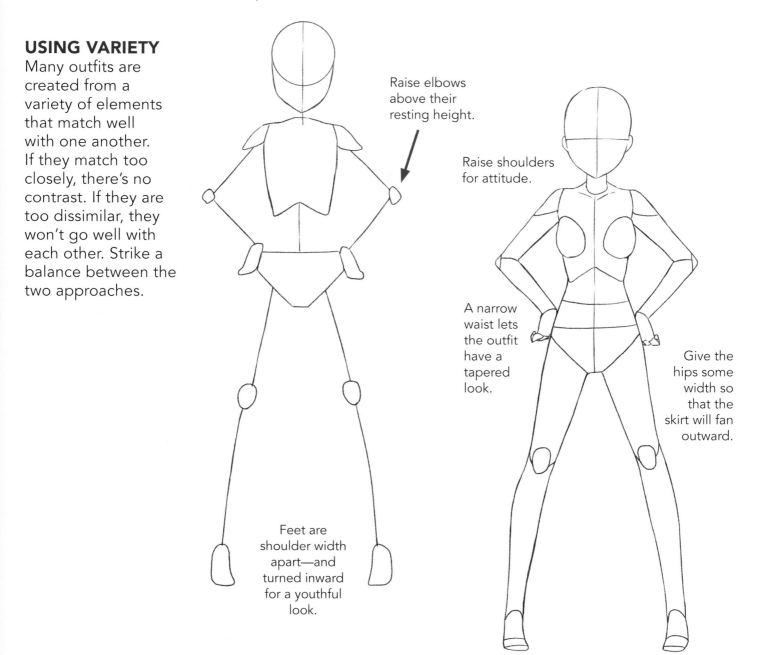

Raise elbows above their resting height.

Raise shoulders for attitude.

A narrow waist lets the outfit have a tapered look.

Give the hips some width so that the skirt will fan outward.

Feet are shoulder width apart—and turned inward for a youthful look.

ALTERNATING LONG & SHORT CLOTHING

The vest is short, but the shirt underneath is long. The skirt is short, but the leggings are long. Combining short items with long items creates interest. Note the high number of folds in the sleeves. Extra folds are created when a joint is bent, like the arms.

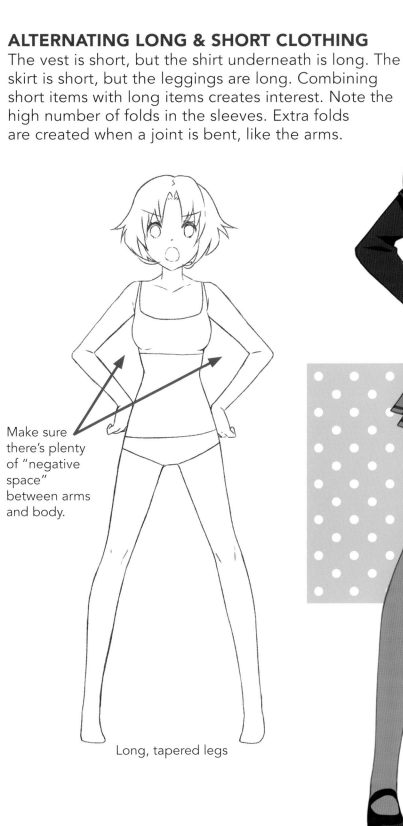

Make sure there's plenty of "negative space" between arms and body.

Long, tapered legs

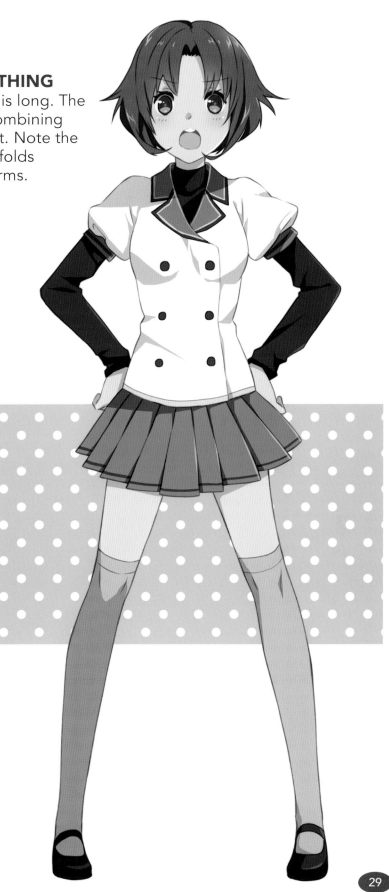

SWEATERS & SKIRTS

Sweaters and skirts go together like sea urchin and rice. (That's the Japanese version of PB & J.) A sweater vest is often slightly oversized. And schoolgirls frequently wear them with pleated skirts. This fun pose shows motion, which will be reflected in the way the skirt flaps. Let's first build the pose based on the template model.

Running with one hand free (the bent arm will hold the tote bag) is an awkward—and therefore a funny—pose.

The tilt of the hips will cause the skirt to flap.

Point the knee inward for a funny run.

She leans to the left, which will cause the valise to swing to the right. This is based on an animation principle known as "secondary action."

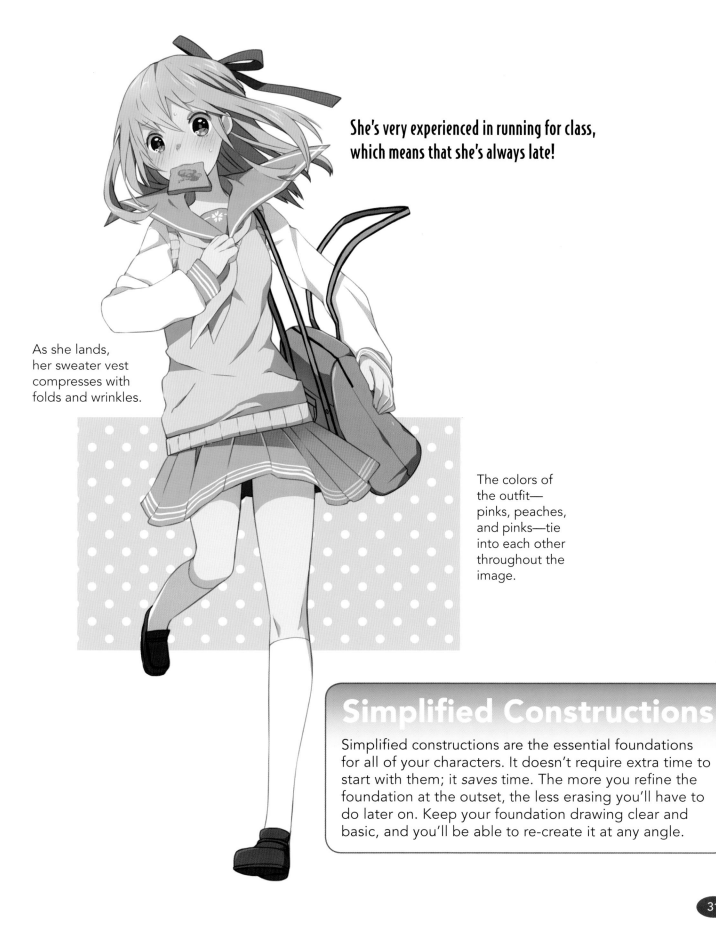

She's very experienced in running for class, which means that she's always late!

As she lands, her sweater vest compresses with folds and wrinkles.

The colors of the outfit—pinks, peaches, and pinks—tie into each other throughout the image.

Simplified Constructions

Simplified constructions are the essential foundations for all of your characters. It doesn't require extra time to start with them; it *saves* time. The more you refine the foundation at the outset, the less erasing you'll have to do later on. Keep your foundation drawing clear and basic, and you'll be able to re-create it at any angle.

More Outfits

SWEATER VEST

The sweater vest is a versatile piece of clothing and a popular choice for school uniforms.

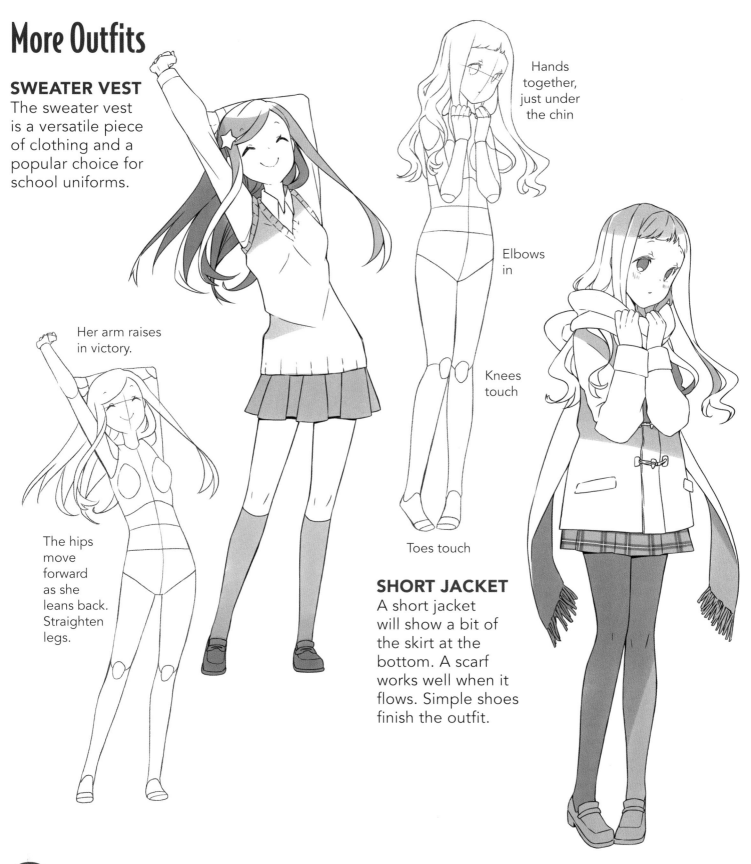

Her arm raises in victory.

The hips move forward as she leans back. Straighten legs.

Hands together, just under the chin

Elbows in

Knees touch

Toes touch

SHORT JACKET

A short jacket will show a bit of the skirt at the bottom. A scarf works well when it flows. Simple shoes finish the outfit.

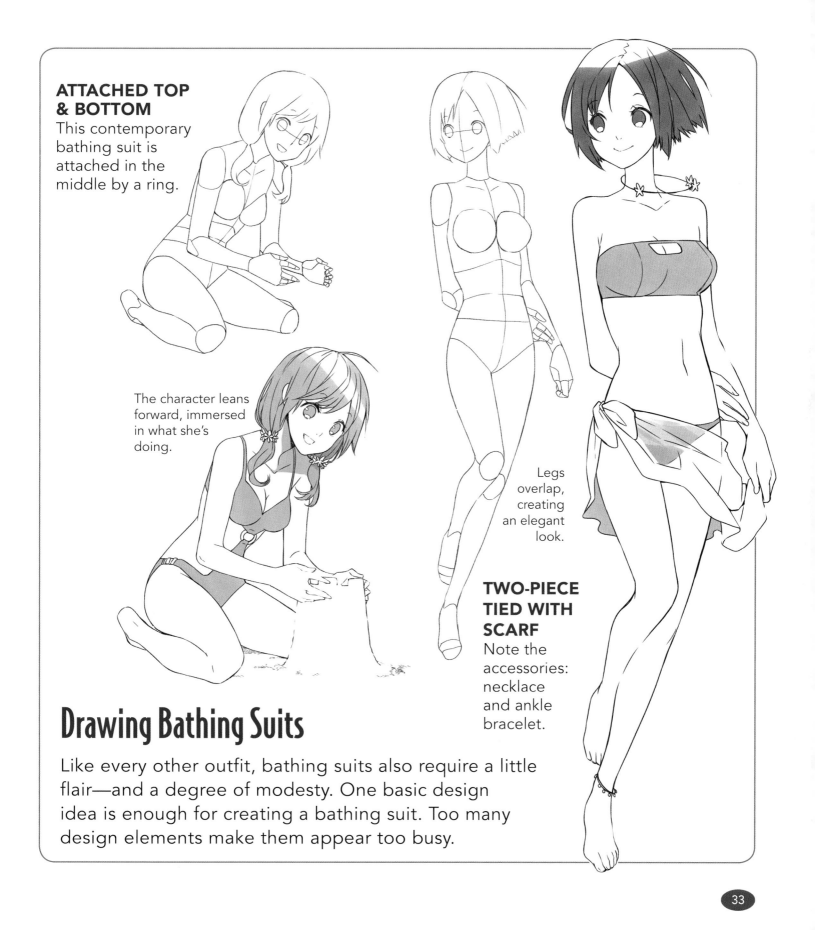

ATTACHED TOP & BOTTOM
This contemporary bathing suit is attached in the middle by a ring.

The character leans forward, immersed in what she's doing.

Legs overlap, creating an elegant look.

TWO-PIECE TIED WITH SCARF
Note the accessories: necklace and ankle bracelet.

Drawing Bathing Suits

Like every other outfit, bathing suits also require a little flair—and a degree of modesty. One basic design idea is enough for creating a bathing suit. Too many design elements make them appear too busy.

Fashion Selections for the Basic Schoolgirl

For creating eye-catching characters, you can't beat choosing the right outfit. Clothes enhance a character's attractiveness and help to define her personality. It's as much a part of her character design as her facial features or proportions. Although characters may have varied wardrobes, their identity often centers on a specific outfit.

VARIETY IN SCHOOL UNIFORMS

The word *uniform* suggests that there is one standard outfit. There isn't. Within the category of school uniforms, you can create a host of appealing fashions by mixing and matching mostly traditional (and a few not-so-traditional) items, such as blouses, sweaters, vests, skirts, dresses, jackets, leggings, shoes, and accessories.

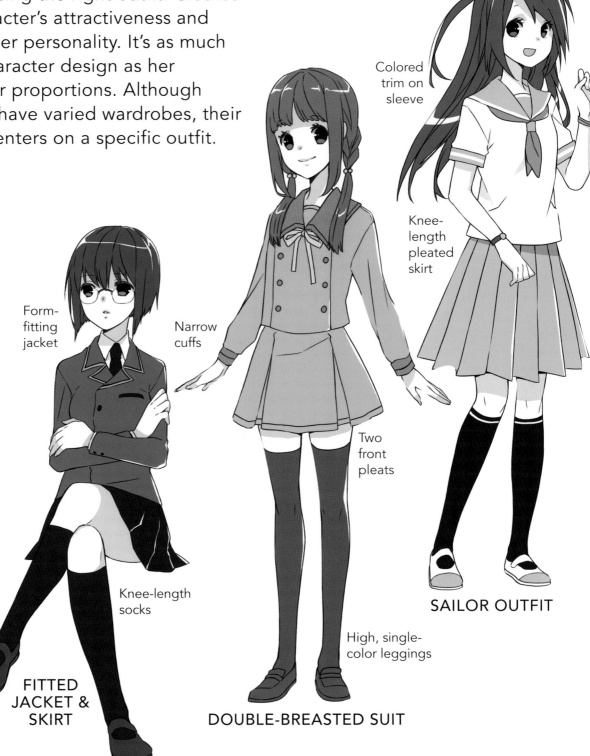

Form-fitting jacket

Narrow cuffs

Knee-length socks

FITTED JACKET & SKIRT

Two front pleats

High, single-color leggings

DOUBLE-BREASTED SUIT

Wide, colored collar

Colored trim on sleeve

Knee-length pleated skirt

SAILOR OUTFIT

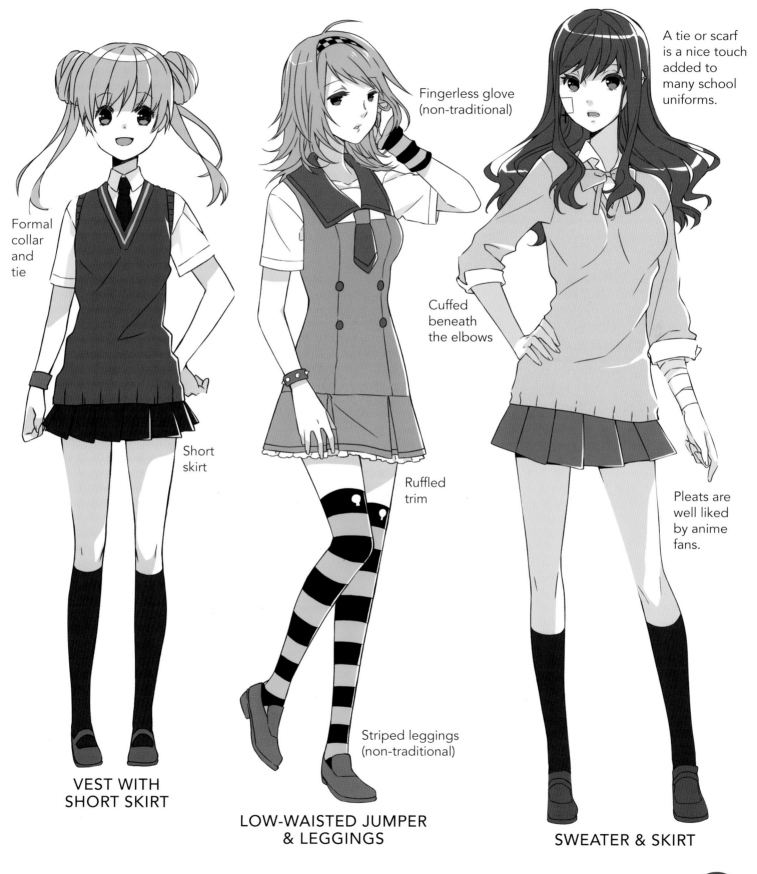

Formal collar and tie

Fingerless glove (non-traditional)

A tie or scarf is a nice touch added to many school uniforms.

Cuffed beneath the elbows

Short skirt

Ruffled trim

Pleats are well liked by anime fans.

Striped leggings (non-traditional)

VEST WITH SHORT SKIRT

LOW-WAISTED JUMPER & LEGGINGS

SWEATER & SKIRT

SCHOOLGIRL UNIFORM VARIATIONS

1 BUTTON-DOWN SWEATER

2 SHORT JACKET

3 PLAID PLEATED SKIRT

4 PLAID DETAIL

5 SHORT PLEATED SKIRT

6 BUTTON-DOWN SWEATER-VEST

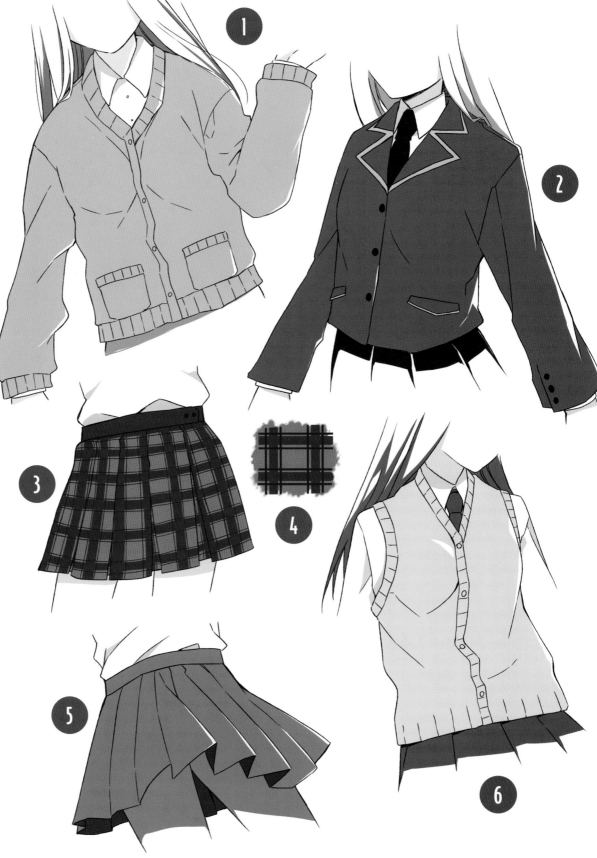

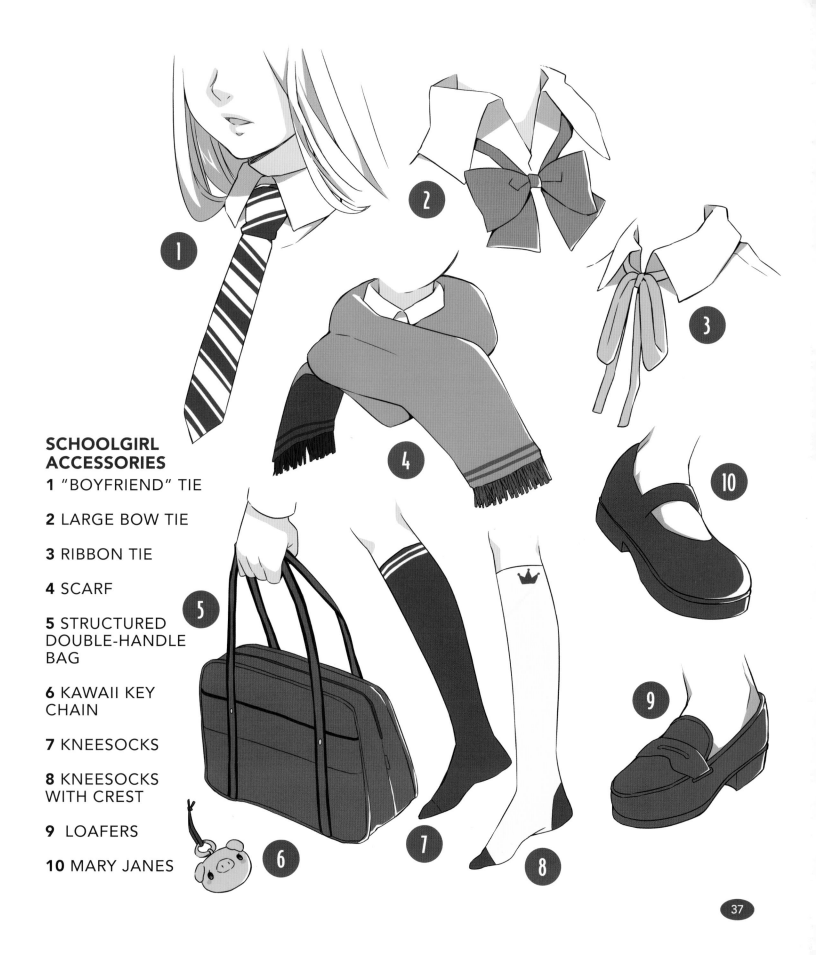

SCHOOLGIRL ACCESSORIES

1 "BOYFRIEND" TIE

2 LARGE BOW TIE

3 RIBBON TIE

4 SCARF

5 STRUCTURED DOUBLE-HANDLE BAG

6 KAWAII KEY CHAIN

7 KNEESOCKS

8 KNEESOCKS WITH CREST

9 LOAFERS

10 MARY JANES

Using Emotions to Create Original Characters

Each of the schoolgirls in this last section of the chapter represents a different personality type. We have already tweaked the head and body and created outfits. But there's one more step. And that's to give your character an action pose or posture that defines her personality. Let's look at four basic character types and discover how their actions express who they are.

Hair trails behind, which is called "secondary action" and indicates movement.

Foot is high off the ground, indicating a quick run.

HARRIED & HAPPY
This type is always on the move. She's happy and somewhat disorganized, which adds humor to the character.

One leg extends.

Arm is back to counterbalance extended leg.

She looks back as she speaks—there's no time to stop and turn around! The leaves dust up around her to reflect the chaos of the scene.

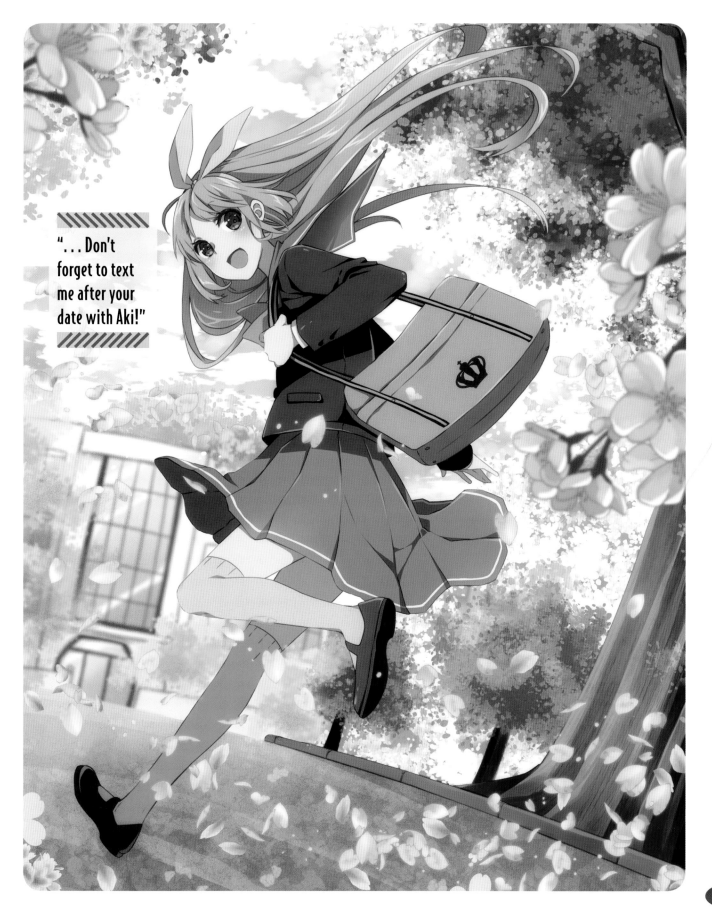

"...Don't forget to text me after your date with Aki!"

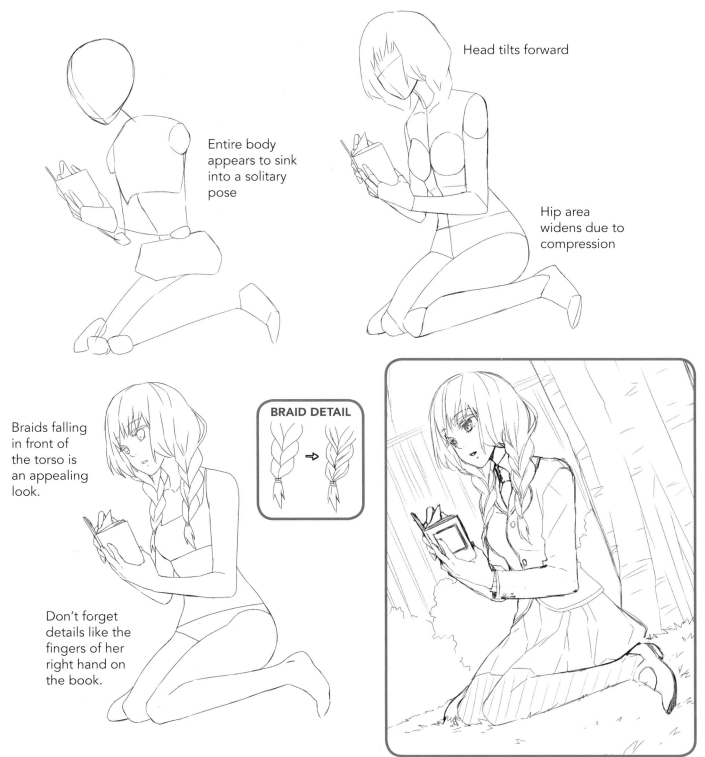

Entire body appears to sink into a solitary pose

Head tilts forward

Hip area widens due to compression

Braids falling in front of the torso is an appealing look.

BRAID DETAIL

Don't forget details like the fingers of her right hand on the book.

THE UNNOTICED

Not the same as the loner, who enjoys being apart from the group, the unnoticed type craves companionship but can't find it. Perhaps she's painfully shy and can't get herself to open up, and everyone mistakes her attitude as being snooty. That's a common setup in anime stories. And in real life!

"Dear Diary . . . someday he'll realize that I'm the one who truly loves him, not that brain-dead blonde he's seeing!"

NATURAL-BORN GOSSIPS

The "mean girl" is a popular character type, sometimes referred to in Japanese as tsundere. If you've ever been to high school, you've encountered her wickedness. In this scene, two gossips are verbally dismantling another student. Mean girls are often seen in pairs: the caustic leader and the bubbleheaded follower.

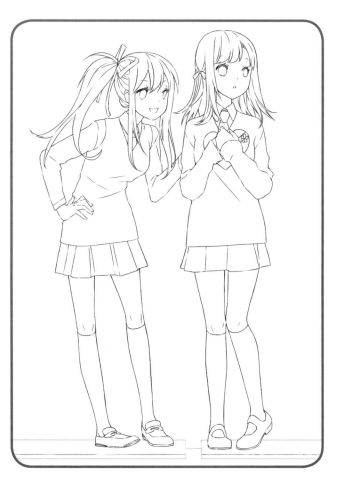

One character is the leader, and the other is the follower. You should be able to tell who is who from their body language.

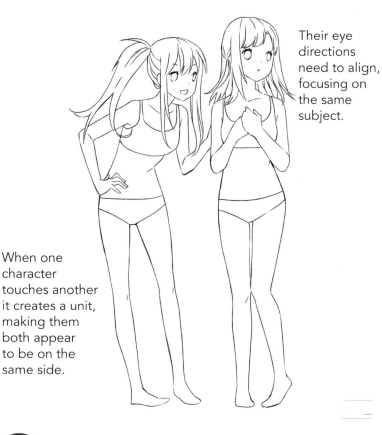

Their eye directions need to align, focusing on the same subject.

When one character touches another it creates a unit, making them both appear to be on the same side.

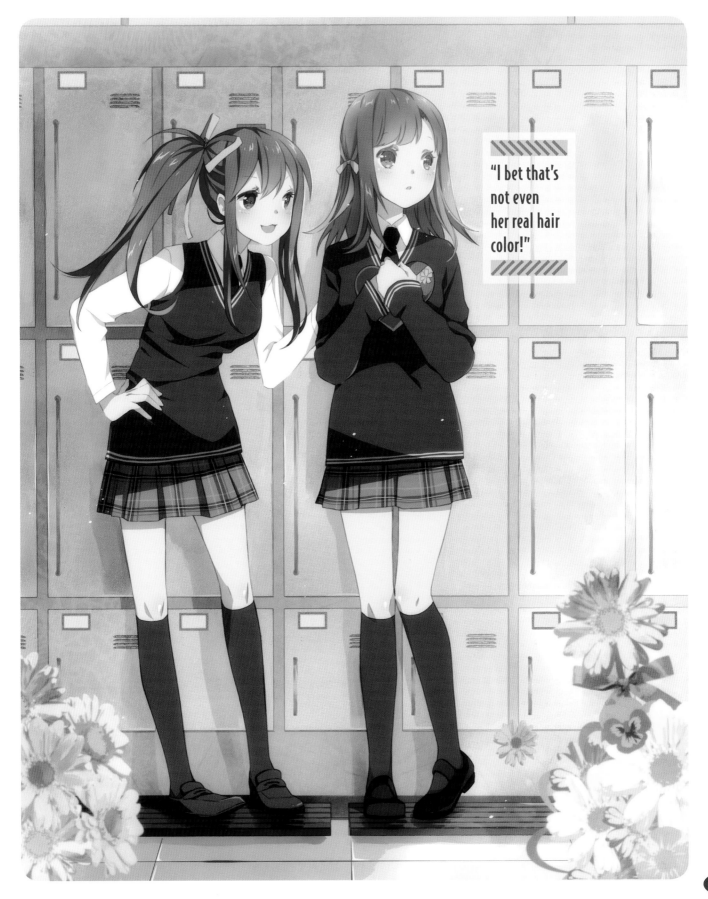

"I bet that's not even her real hair color!"

PLAYFUL TYPES

Wherever they are, these best friends enjoy a good laugh. These cheerful types are used to keep stories rolling in a humorous way. Their poses are relaxed and spontaneous.

The students face each other in a ¾ view, which allows the viewer to see more of their faces than if they were in strict profiles.

Both figures lean toward each other, perhaps sharing a secret.

The characters never really listen to the lecture.

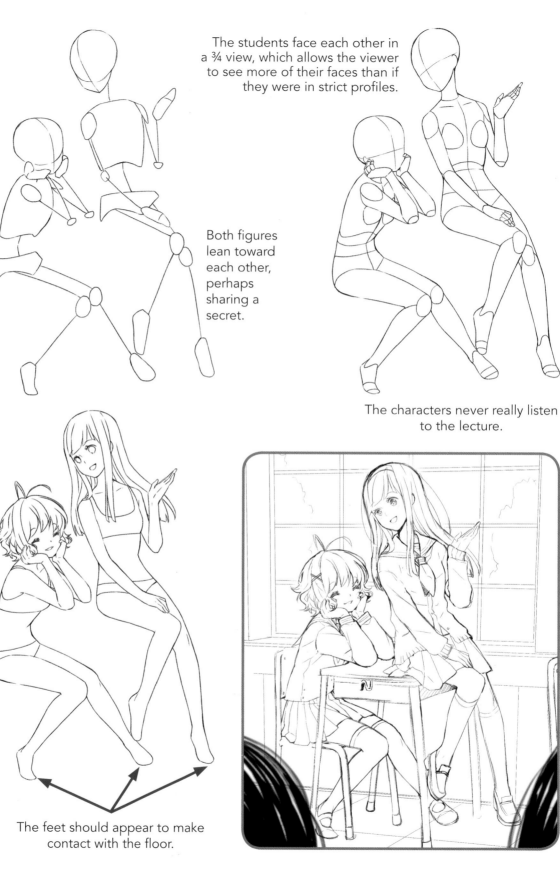

The feet should appear to make contact with the floor.

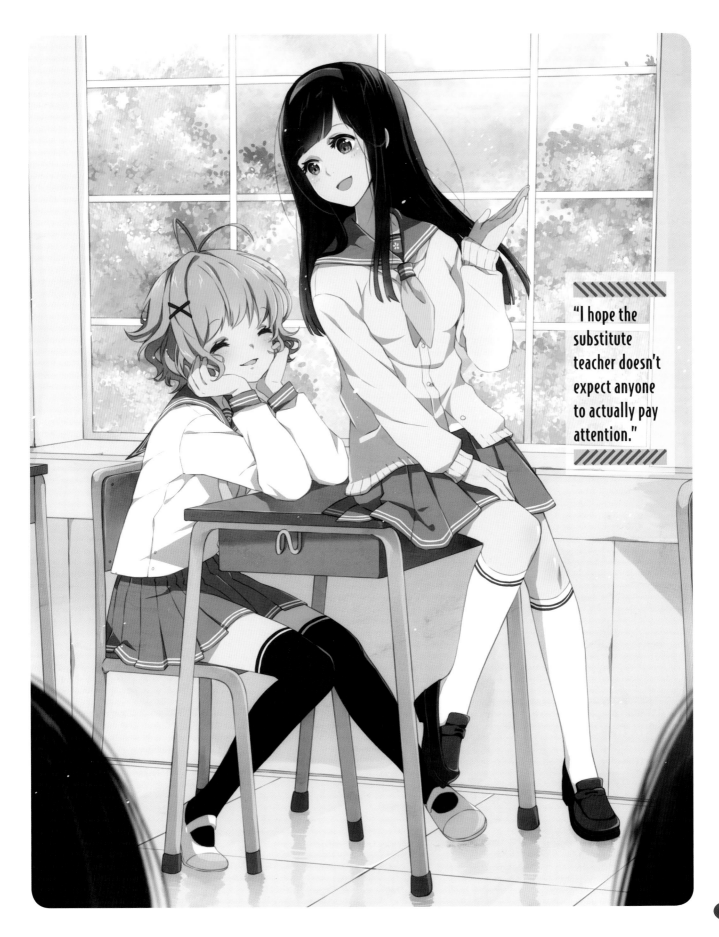

"I hope the substitute teacher doesn't expect anyone to actually pay attention."

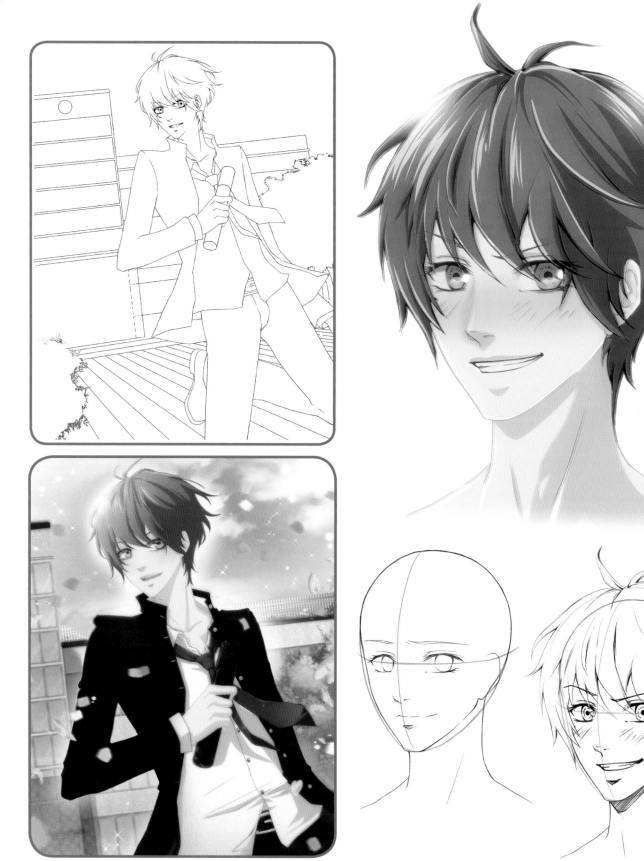

Schoolboys

Schoolboys share common characteristics:
They have an affable and bright-eyed appearance.
The physique has yet to fill out. (Usually only
the upper classmen are tall.) He's still awkward.
the clothes are a little unkempt—for example,
shirt out, sleeves rolled up, tie loosened, and so
on. Keep these general parameters in mind when
thinking up your own schoolboy characters. ■

Head Proportions 360º Template

The typical schoolboy's head is based on an egg shape. The bottom half of the head tapers sharply to a narrow chin. Overall, the face has a soft look. The large forehead is covered with messy hair. The eyes are large, though not as brilliant as his female equivalent. He can only stay neat and tidy for the first few hours of the school day. After that, he starts to unravel!

BASIC CONSTRUCTION **FRONT** **¾ RIGHT FRONT** **RIGHT PROFILE**

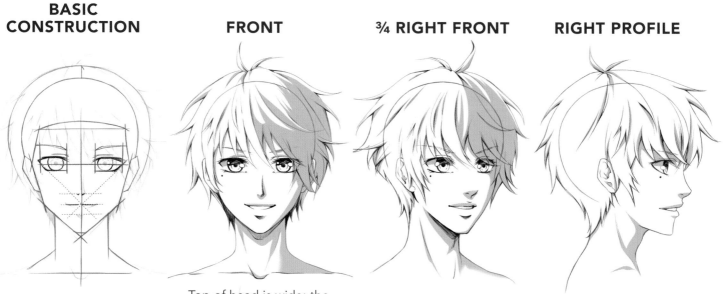

Top of head is wide; the
bottom half is narrow.

He's a boy. What did you expect?

It's axiomatic that the better looking and older the schoolboy is, the more the girls want him—and the more oblivious he is to their overtures. Conversely, the younger the schoolboy is, the more likely it is that he's the one doing the pursuing—without much success to show for his efforts.

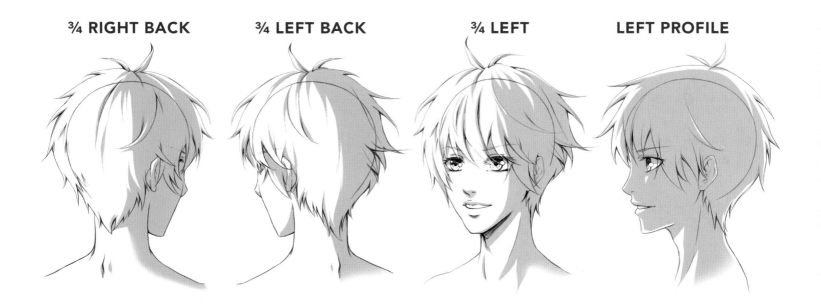

¾ RIGHT BACK **¾ LEFT BACK** **¾ LEFT** **LEFT PROFILE**

Points to Keep in Mind

■ The eyebrows are thin and somewhat androgynous.

■ The eye shape is more horizontal (side-to-side) than vertical (up and down).

■ If he has a lot of hair, sometimes that can obscure his ears and fall over his eyebrows.

■ The neck is trim. (He hasn't filled out yet.)

Basic Schoolboy Character (3/4 View)

The basic template for the head is set in place in the first few steps. Once the basic structure is in place, you can individualize your character by adjusting these elements:
- Hairstyle (including volume of hair)
- Hair color
- Eye color
- Expression

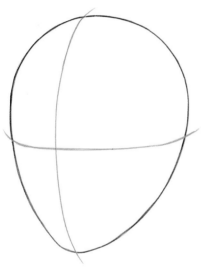

Start your head with the vertical center line curving around the egg-shaped head. The center line is drawn about two-thirds of the way over to the left on the head. The horizontal eye line should be drawn about halfway up the head.

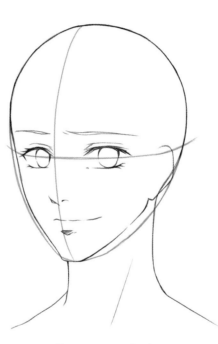

Carve out a sleeker look to the lower half of the face. Due to perspective, the far eye almost touches the center line.

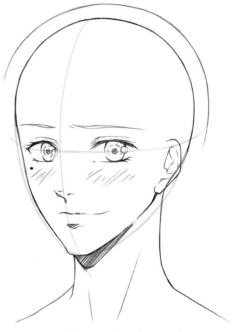

Notice that the neck connects to the head just behind the ear.

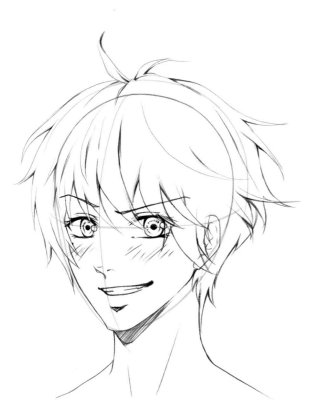

The hair is layered and combed
in no particular direction.

The final character
is appealing and
slightly humorous.

**A harmless smile is a good look for
this character type.**

To Redraw or Not to Redraw

Here's a common problem everyone comes across. Let's say you've just drawn the basic head shape with a glistening pair of eyes. You even call your parents and tell them your anime is improving, and they respond, "What's anime?" And then your mom says, "Wear a hat when you go outside today. It's cold." You blow off the hat suggestion and return to your drawing. Then you realize that you drew the eyes too close together. To fix it, you would have to erase and redraw

them. But they are so dazzling looking.

It's at this point that the serious artist and the newbie part ways. The newbie works around the error. The serious artist sheds a few tears, erases, and redraws. I would love to be able to give you an easy fix for correcting a drawing you don't want to change. But the easy fix is to stop resisting, erase it, and redraw it. It's never going to look right unless you make it right. And your mom is actually correct about wearing a hat.

Basic 360° Schoolboy Body Template

The schoolboy isn't done growing; he hasn't reached his full height, and his physique is not terribly impressive. And his brain, well, don't even go there. Just like his face, his body has a soft look. There's nothing really rugged about it. His proportions are well balanced without the exaggerated length of some other popular, mature male character types.

Seniors have the most social status, while juniors and sophomores have only some and freshmen are considered "fresh meat." The height and build communicate the age to the viewer.

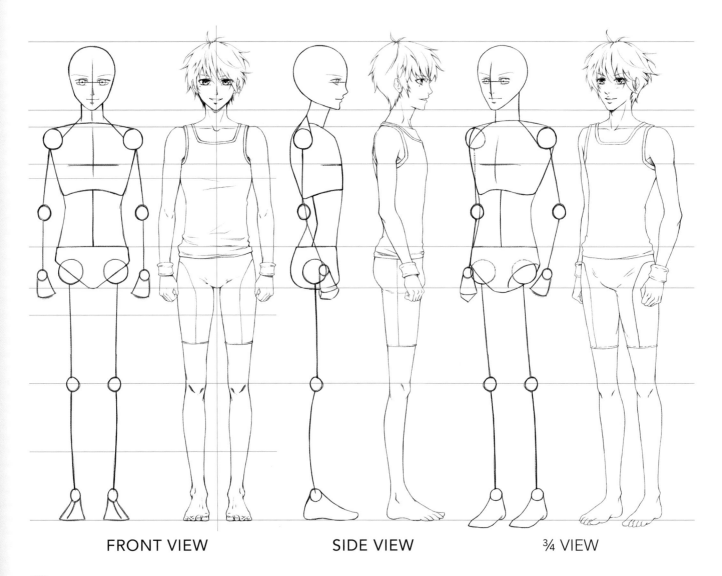

FRONT VIEW SIDE VIEW ¾ VIEW

Clothing

The schoolboy's waking hours are preoccupied with thoughts of girls, food, and cars. Trendy clothes, not so much. He's not going to spend his video game money on them. Generally, everything looks like it could use some ironing. We can boil down his wardrobe to three basic categories: sporty, school clothes, and everything else.

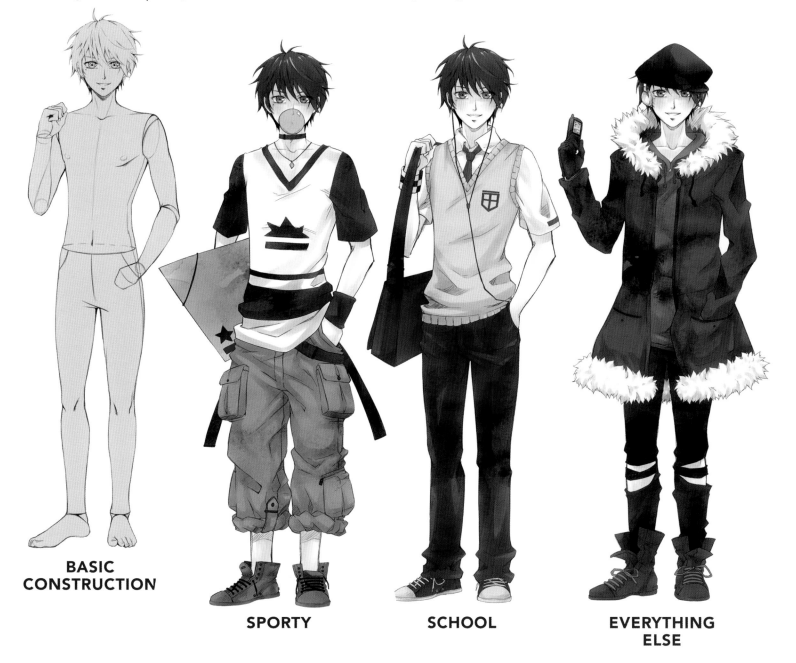

**BASIC
CONSTRUCTION**

SPORTY

SCHOOL

**EVERYTHING
ELSE**

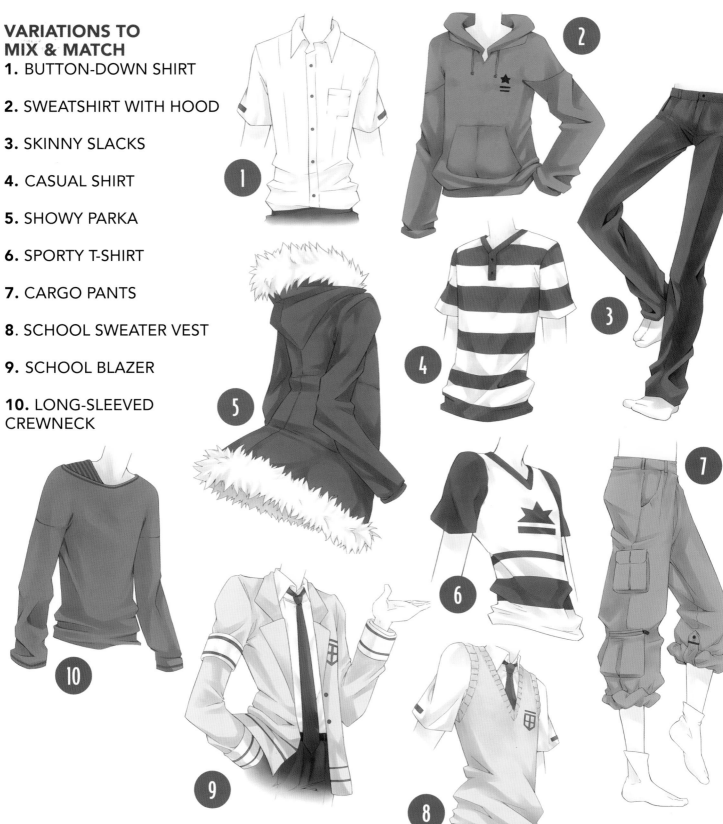

VARIATIONS TO MIX & MATCH

1. BUTTON-DOWN SHIRT

2. SWEATSHIRT WITH HOOD

3. SKINNY SLACKS

4. CASUAL SHIRT

5. SHOWY PARKA

6. SPORTY T-SHIRT

7. CARGO PANTS

8. SCHOOL SWEATER VEST

9. SCHOOL BLAZER

10. LONG-SLEEVED CREWNECK

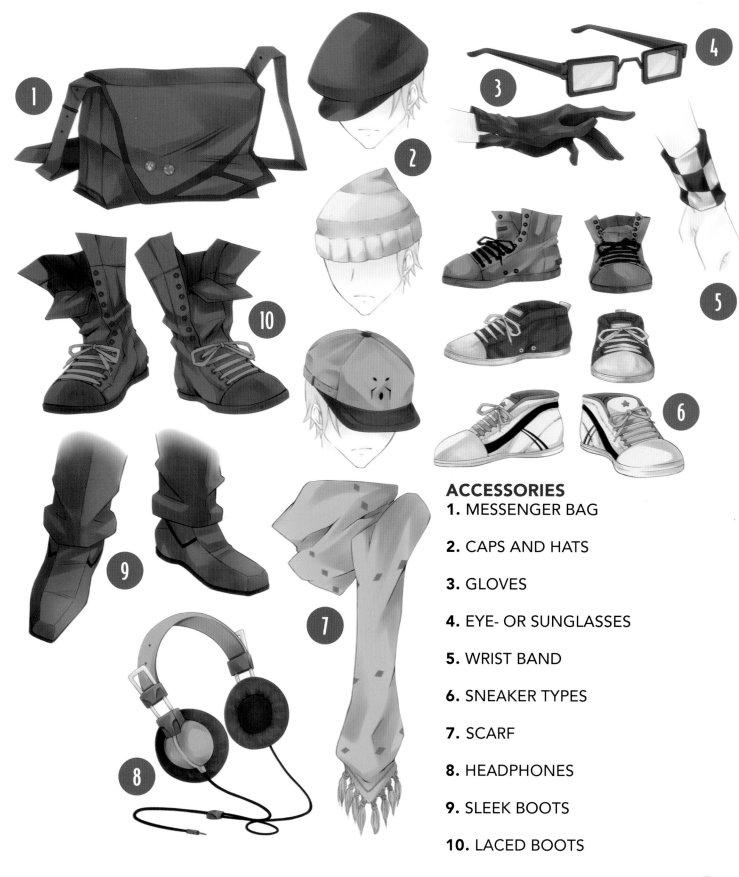

ACCESSORIES

1. MESSENGER BAG

2. CAPS AND HATS

3. GLOVES

4. EYE- OR SUNGLASSES

5. WRIST BAND

6. SNEAKER TYPES

7. SCARF

8. HEADPHONES

9. SLEEK BOOTS

10. LACED BOOTS

Classic Schoolboy

Guys hate class picture day. It's the one day in high school when your mom insists on dressing you. But even at times like this, our teenage boy has found a way to make his freshly pressed outfit unkempt and wrinkled. That takes talent. And yet, he has a casual charisma that allows him to pull it off—with style to spare. Focus on his predominant qualities: modest good looks; a breezy hairstyle; a slender build; the smart outfit, worn casually; and a casual pose.

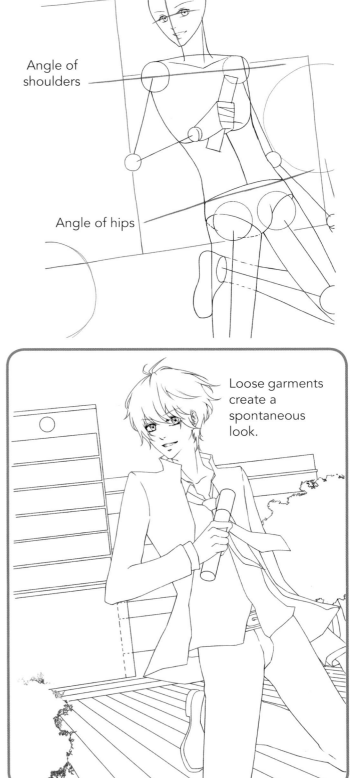

Angle of shoulders

Angle of hips

Breezy hair

Raised shoulders make the collarbones tilt downward.

Loose garments create a spontaneous look.

Note how the cool look of the schoolboy is enhanced by his offhanded pose.

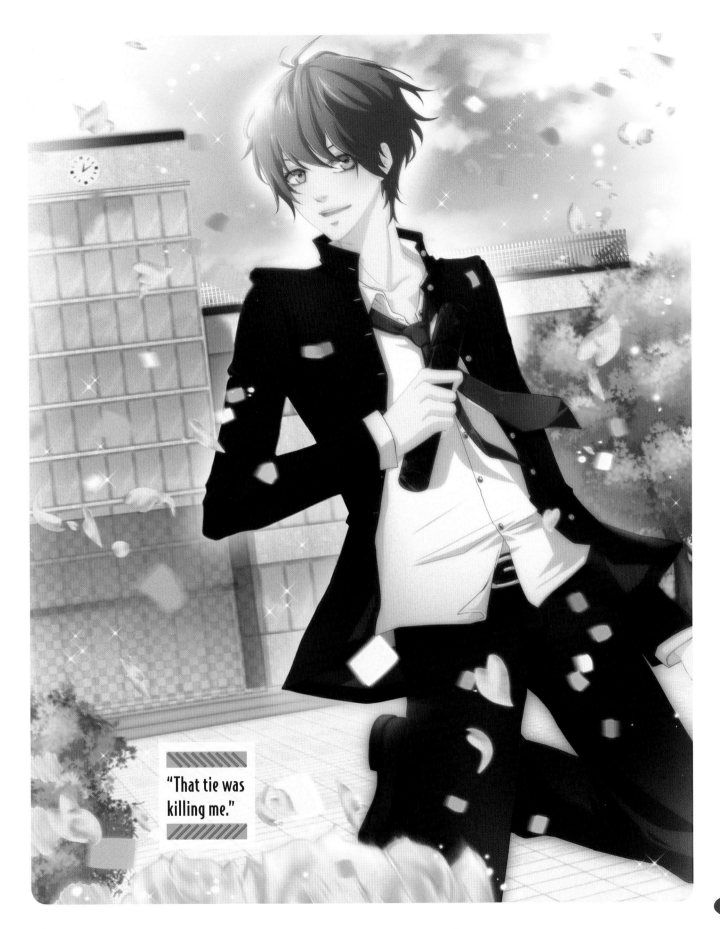

"That tie was killing me."

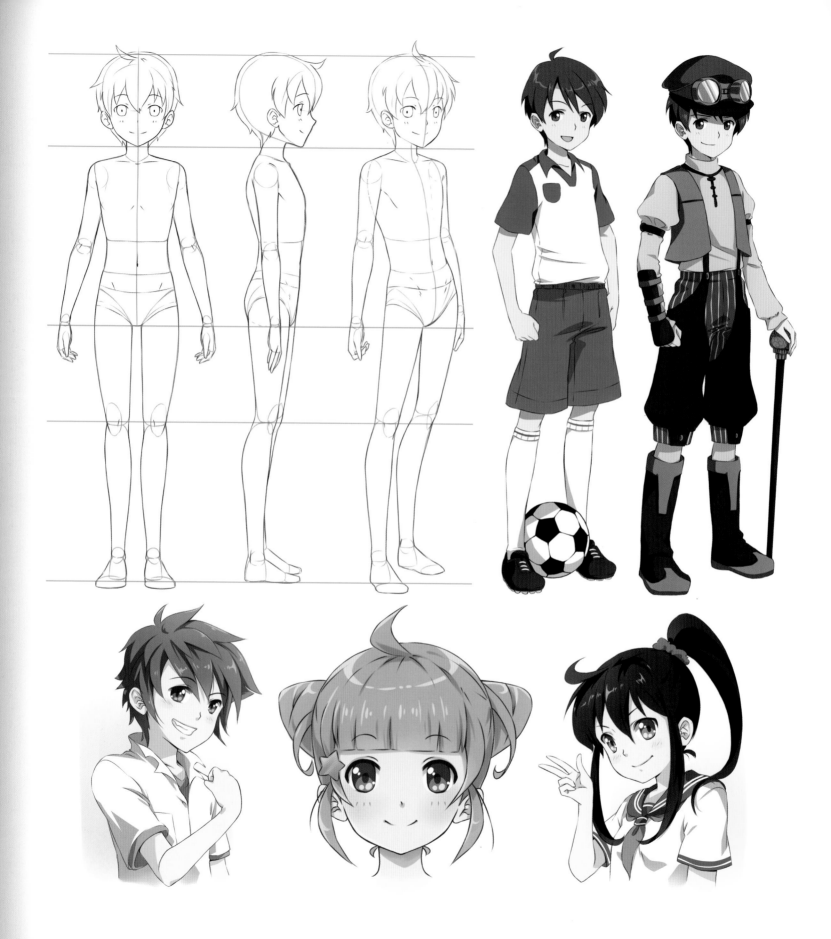

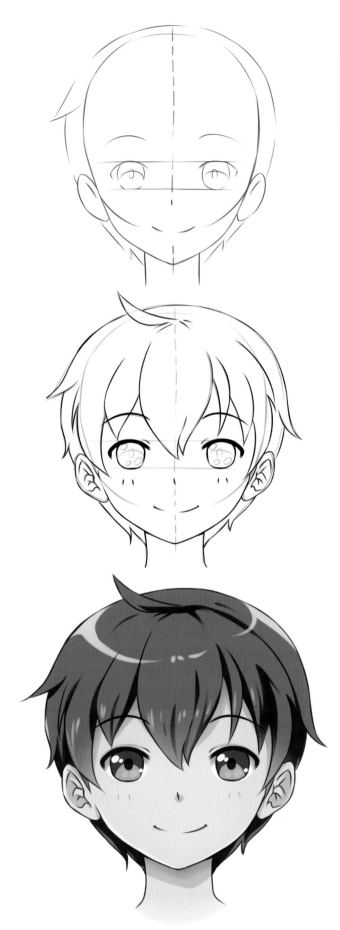

Preteens

Younger characters have their own age-specific genre, which is popular, called kodomo.

But they also appear as supporting characters across a wide spectrum of anime stories as younger siblings, neighborhood kids, and as the youngest member of a group of slightly older students. These characters are famous for being funny, curious, mischievous, and sometimes even brave. They often face a big moral dilemma in a story. The choice they make leads them on amazing, and often harrowing, adventures—with good or bad results. The comedy is broad, and pratfalls are not an uncommon occurrence.

Popular preteen personality types are many: silly, nervous, foolishly brave, pessimistic, loyal, and distractible. ■

Preteen Head Proportions 360° Template

FEMALE PROPORTIONS

Preteen anime girls share general characteristics that give them a consistant look: round faces (with wide lower faces), extra-large eyes, oversized hair, big emotions, small stature, soft body construction, and small hands and feet.

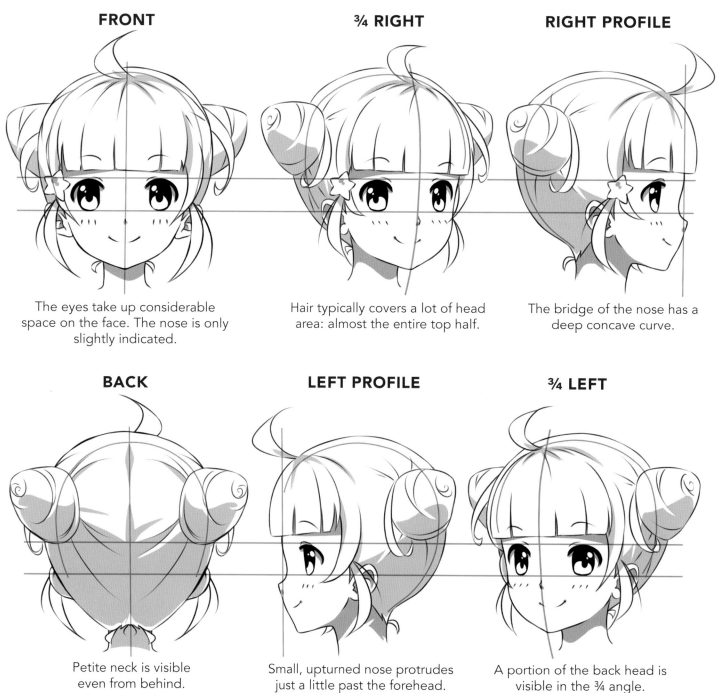

FRONT

The eyes take up considerable space on the face. The nose is only slightly indicated.

¾ RIGHT

Hair typically covers a lot of head area: almost the entire top half.

RIGHT PROFILE

The bridge of the nose has a deep concave curve.

BACK

Petite neck is visible even from behind.

LEFT PROFILE

Small, upturned nose protrudes just a little past the forehead.

¾ LEFT

A portion of the back head is visible in the ¾ angle.

GIRL STEP BY STEP

With preteens, cuteness rules. The eyes are cute. The expression is cute. Even the hair is cute. I can't take so much cute! The key to creating cuteness lies in the construction of the character. The upper portion of the head is drawn as a big circle. The lower portion of the head adds only a little mass to the outline. The upper part of the head (forehead) is predominant. That's the key to creating a foundation of cuteness.

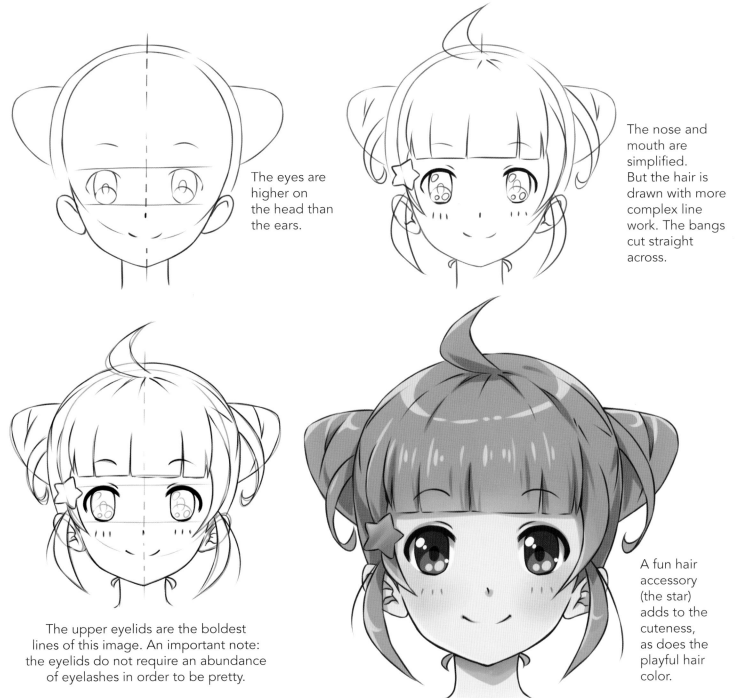

The eyes are higher on the head than the ears.

The nose and mouth are simplified. But the hair is drawn with more complex line work. The bangs cut straight across.

The upper eyelids are the boldest lines of this image. An important note: the eyelids do not require an abundance of eyelashes in order to be pretty.

A fun hair accessory (the star) adds to the cuteness, as does the playful hair color.

MALE PROPORTIONS

The preteen boy's head construction is similar, but the lower half of his face (from the ears to the chin) is slightly narrower than the preteen girl. Also, his eyes are somewhat smaller.

FRONT **3/4 RIGHT** **RIGHT PROFILE**

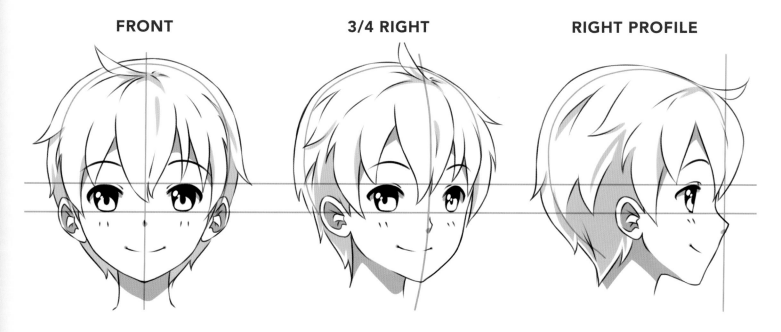

BACK **LEFT PROFILE** **3/4 LEFT**

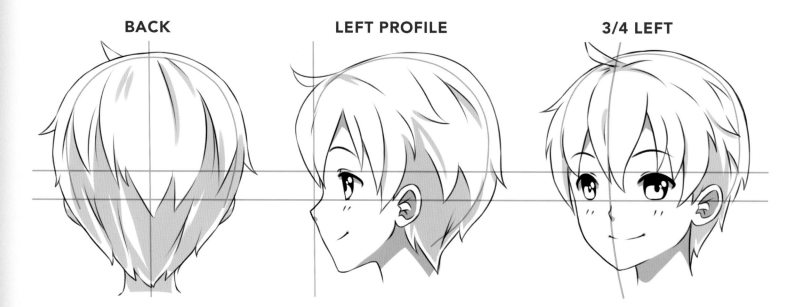

BOY STEP BY STEP

Once you establish the basic proportions of the head, you can focus on creating the features of the face and an appealing hairstyle with the confidence that the overall look of the head will be correct. When the framework is in place, the rest flows together easily.

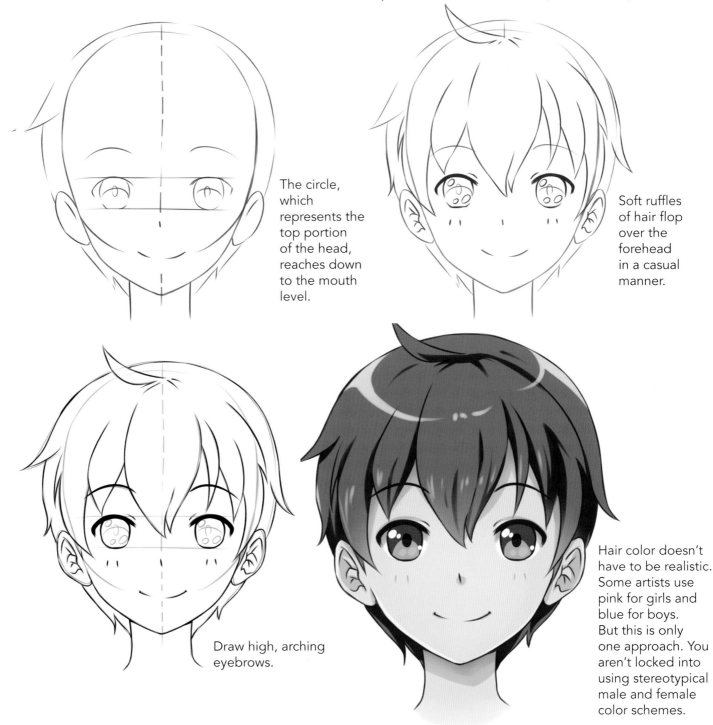

The circle, which represents the top portion of the head, reaches down to the mouth level.

Soft ruffles of hair flop over the forehead in a casual manner.

Draw high, arching eyebrows.

Hair color doesn't have to be realistic. Some artists use pink for girls and blue for boys. But this is only one approach. You aren't locked into using stereotypical male and female color schemes.

Body Proportions Templates

Preteens exude an energetic and cute posture. A common mistake new artists make is to draw the body with lots of straight lines. If you look at a diagram of a skeleton, you'll see that the limbs and even the spine have subtle curves. Here are some more tips:

• The shoulders are square, but small.
• The head is large, relative to the overall size of the body.
• The torso is slightly undersized.
• The feet turn slightly inward.

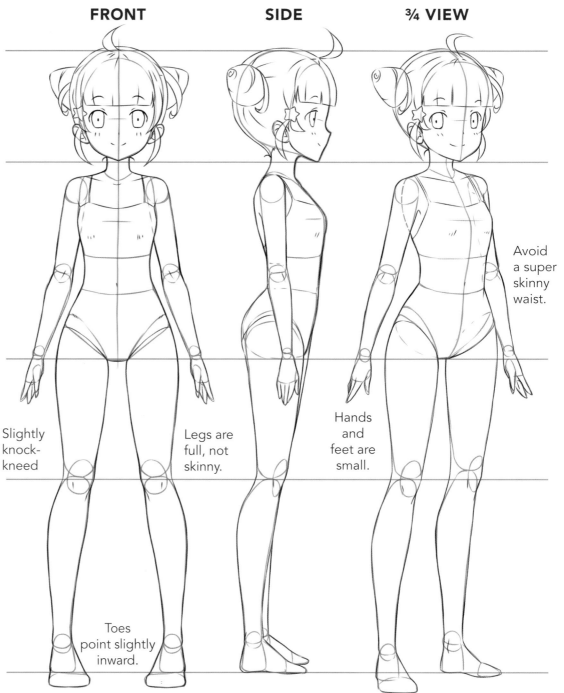

FRONT **SIDE** **¾ VIEW**

Avoid a super skinny waist.

Slightly knock-kneed

Legs are full, not skinny.

Hands and feet are small.

Toes point slightly inward.

PRETEEN GIRL
Young female characters generally have hips that are wider than their shoulders.

FRONT **SIDE** **¾ VIEW**

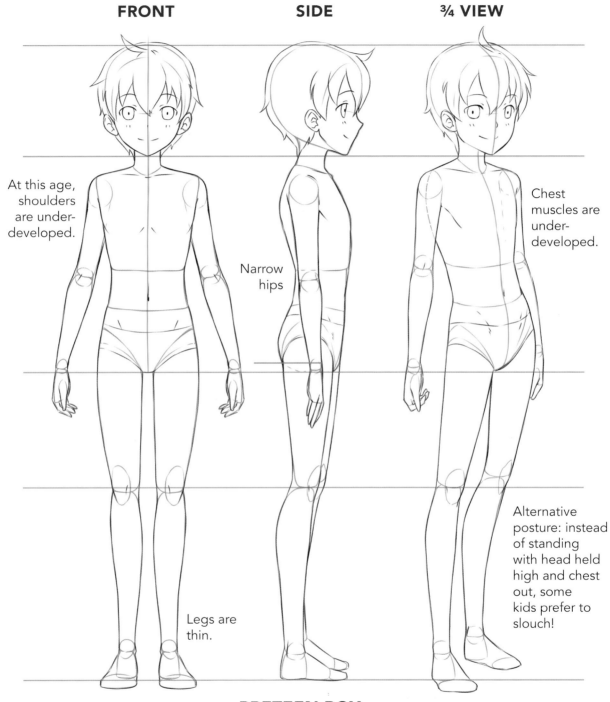

At this age, shoulders are under-developed.

Narrow hips

Chest muscles are under-developed.

Legs are thin.

Alternative posture: instead of standing with head held high and chest out, some kids prefer to slouch!

PRETEEN BOY

He's fairly skinny. Unbeknownst to him, this is the last time in his life he'll be able to eat unlimited quantities of food without worrying about his waistline. Enjoy it while it lasts, little fella. When you get older, your favorite meals will consist of kale and egg whites.

Preteen Eyes

When you compare the eyes of young boys and girls, you see that the girl eyes are usually drawn larger (as measured from top to bottom). But with both boys and girls, the technique is the same: first, sketch top and bottom guidelines and draw the eyes between them. The upper eyelid is arched, the bottom eyelid is less so. Add multiple shines to the irises to give the eyes that glistening appeal. Whether drawn in pencil or in color, gradate the tone of the eye from dark on top to light at the bottom, or reverse it.

BASIC ELEMENTS OF THE ANIME EYE

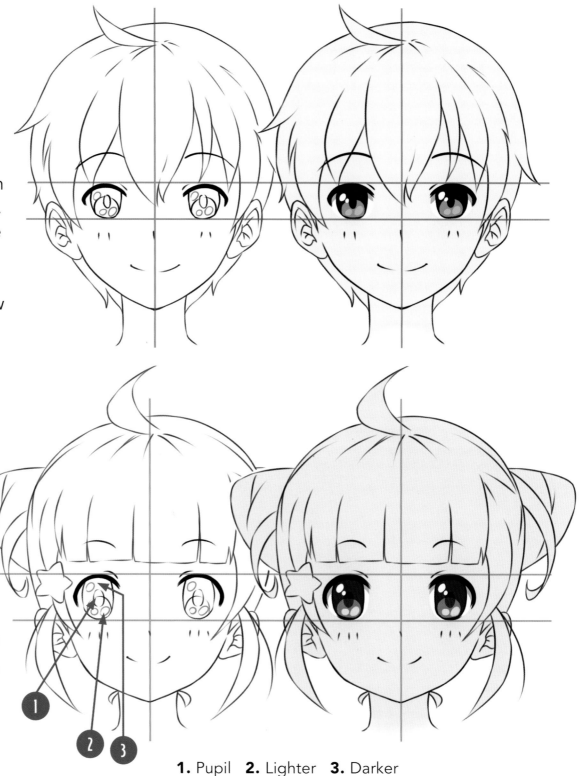

1. Pupil **2.** Lighter **3.** Darker

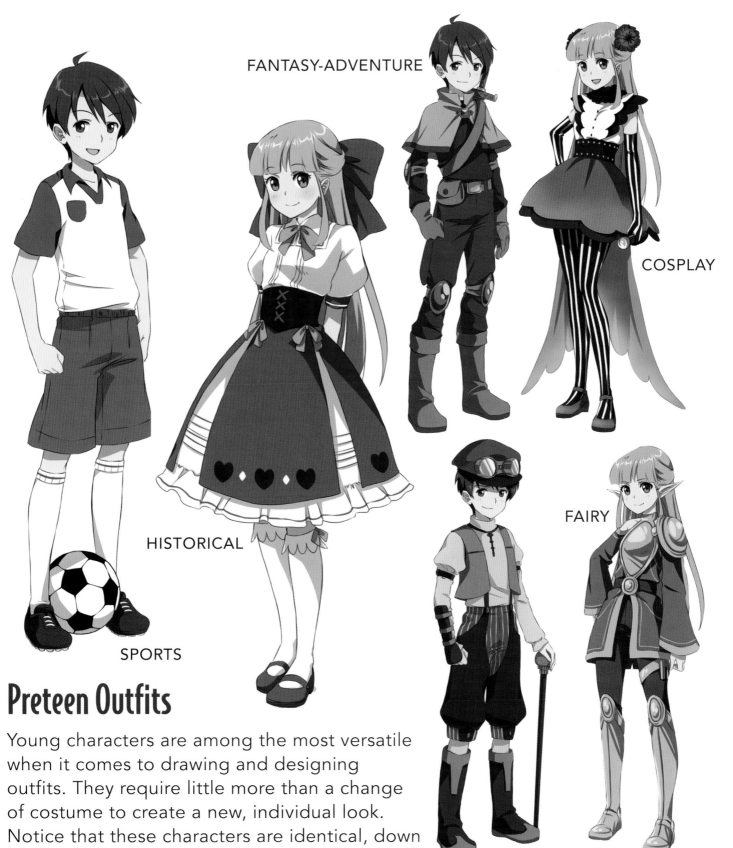

FANTASY-ADVENTURE

COSPLAY

HISTORICAL

FAIRY

SPORTS

STEAMPUNK

Preteen Outfits

Young characters are among the most versatile when it comes to drawing and designing outfits. They require little more than a change of costume to create a new, individual look. Notice that these characters are identical, down to the hairstyle. Only the clothes have changed!

Preteen Personality Types

It's safer to keep the character type broad. Don't make it so unique that people can't relate to it. To do this, start by coming up with a broad "umbrella" term to describe your character, such as Hero. Get more specific as you fine-tune the character type (subtype). For example, "Hero" becomes "The Reluctant Hero" or "The Accidental Hero" or "The Hero with a Secret Identity." This conveys a personality to go with the overarching character type.

GENERAL CATEGORY: THE POPULAR BOY

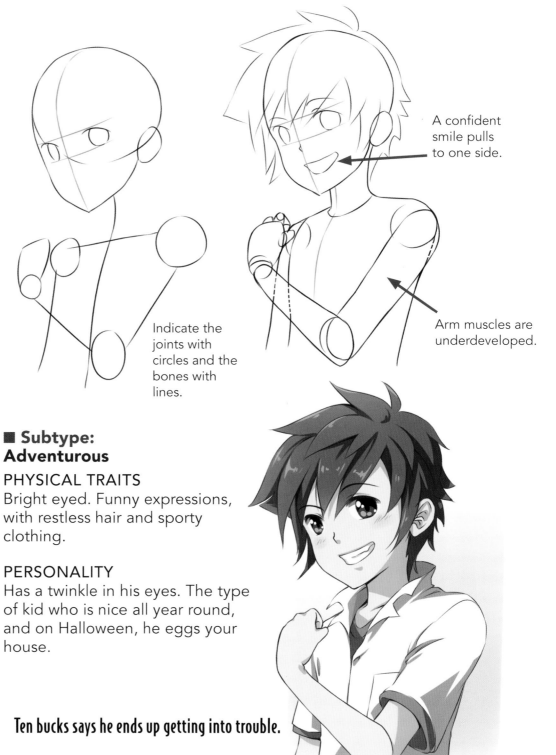

A confident smile pulls to one side.

Arm muscles are underdeveloped.

Indicate the joints with circles and the bones with lines.

■ Subtype: Adventurous

PHYSICAL TRAITS
Bright eyed. Funny expressions, with restless hair and sporty clothing.

PERSONALITY
Has a twinkle in his eyes. The type of kid who is nice all year round, and on Halloween, he eggs your house.

Ten bucks says he ends up getting into trouble.

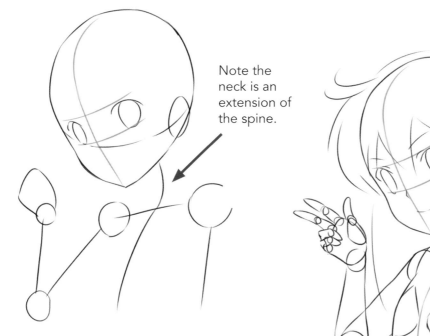

Note the neck is an extension of the spine.

Big eyes are essential. Note the extreme slenderizing of the far eye, due to perspective.

■ Subtype: Clever Teen

PHYSICAL TRAITS
Slightly downturned eyebrows, which shows a bit of cunning. Conventional hairstyle. The smooth line around the back of her head emphasizes its roundness, which is a cute quality. The sailor suit school uniform gives her a cheerful look.

PERSONALITY
Chipper and affable, she's part of a group but remains an individual thinker. Tends to "chibi out" when fuming.

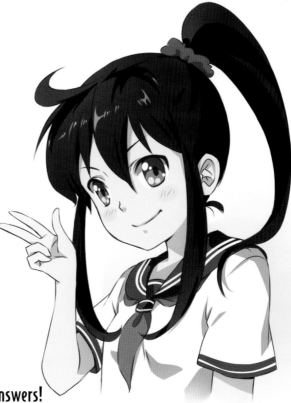

When all looks hopeless, she comes up with answers!

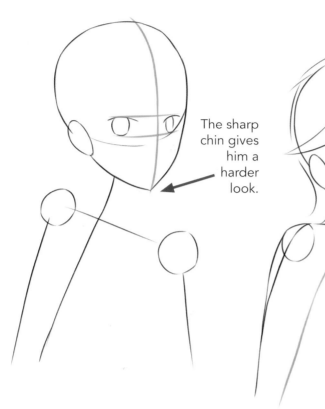

Coiffed hair shows his narcissism.

The sharp chin gives him a harder look.

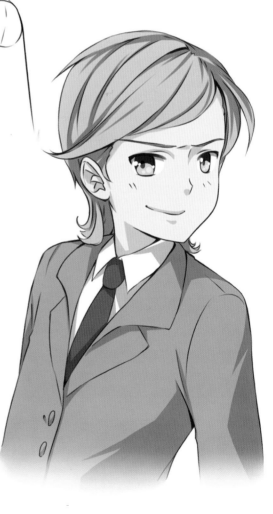

■ Subtype: The Sneak

PHYSICAL TRAITS

This compulsive liar dresses like a "good kid," but it only makes him look slimy! His eyebrows are sharp, and his nose is short and upturned.

PERSONALITY

The consummate actor. The only thing that you can count on him to do is stab you in the back—and blame someone else for it.

A natural poser—and egotist!

GENERAL CATEGORY: FEARFUL

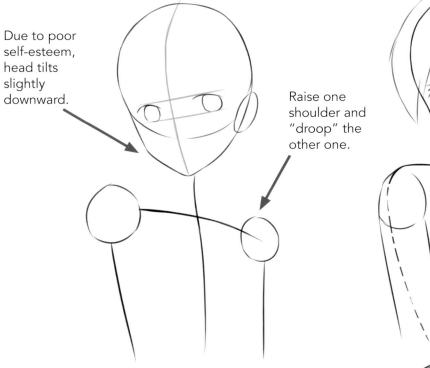

Due to poor self-esteem, head tilts slightly downward.

Raise one shoulder and "droop" the other one.

Tuck chin in, a sign of insecurity.

■ Subtype: Bullied

PHYSICAL TRAITS
Note the thin neck and drooping hair. Non-descript shirt and outfit. He prefers not to stand out.

PERSONALITY
Fearful of rejection, afraid of confrontation. A sympathetic character.

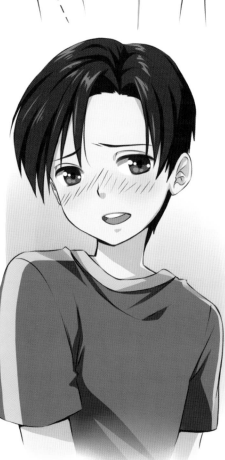

Someone needs to stand up to bullies and be his friend.

GENERAL CATEGORY: MEAN GIRL

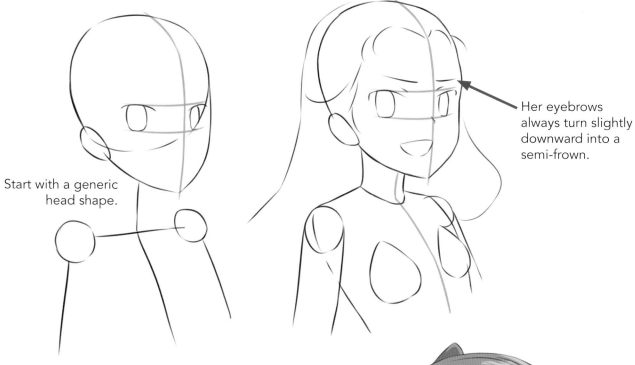

Start with a generic head shape.

Her eyebrows always turn slightly downward into a semi-frown.

■ Subtype: Group Leader

PHYSICAL TRAITS
Show lots of forehead. Give her a bow in her hair to contrast with her sarcastic demeanor. Loud red hair underscores her personality.

PERSONALITY
Unlike the sneak, the mean girl has no pretense about who she is. She likes to belittle others, and she likes to be known for it.

She always has it in for somebody.

GENERAL CATEGORY: TIMID/SHY

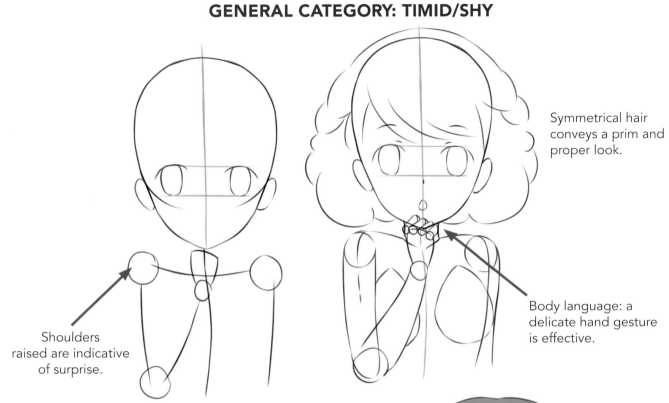

Symmetrical hair conveys a prim and proper look.

Shoulders raised are indicative of surprise.

Body language: a delicate hand gesture is effective.

■ Subtype: Gullible

PHYSICAL TRAITS
An overall sweet, somewhat childlike look. Big, innocent eyes. Blush added to the face as needed.

PERSONALITY
Too trusting. Super honest. When she says she doesn't have today's assignment because her dog ate her homework, that means her dog really did eat her assignment!

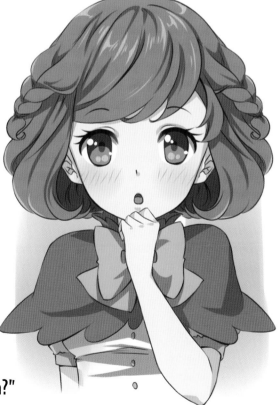

"You really have a pet unicorn?"

GENERAL CATEGORY: BRAINY

A meek build is a stereotype for brainy characters. Nonetheless, it's a look that works.

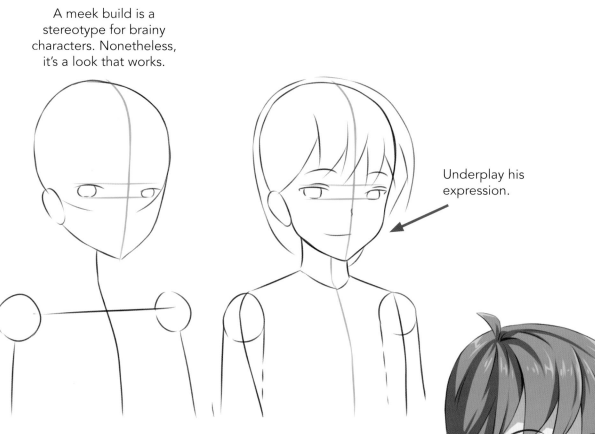

Underplay his expression.

The attire is neat and never flashy.

■ Subtype: Self-Confident

PHYSICAL TRAITS
A subdued smile combined with half-closed eyelids reflect his sarcastic nature. He is small of stature.

PERSONALITY
He doesn't need to shout. He can destroy someone with a few caustic observations.

He mastered string theory when he was only five years old.

GENERAL CATEGORY: THE STUDIOUS GIRL

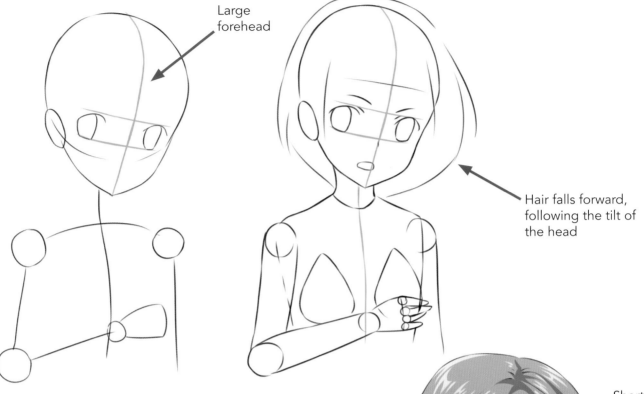

Large forehead

Hair falls forward, following the tilt of the head

Short, feathered bangs

■ Subtype: Know-It-All

PHYSICAL TRAITS
Sapping all trendiness from her hairstyle and outfit produces a character who looks older than her years. Her eyes are intense with short and sharp eyebrows.

PERSONALITY
She has no hesitation about correcting people. This makes her lots of fun at parties. She has zero sense of humor and never gets a joke or a date. Even her dog finds her annoying!

She secretly wants to be like the "cool" girls. And the cool girls secretly want to be smart, like her.

DRAWING EXERCISES: Preteens

POP FASHION GIRL

This character has a great time wherever she goes. To her, life's a beach. She's popular, and people like to be around her. But she's unprepared to invest the necessary time to do her schoolwork or chores. But there needs to be a conflict to set up a story. For example, her parents may have Ivy League ambitions for her.

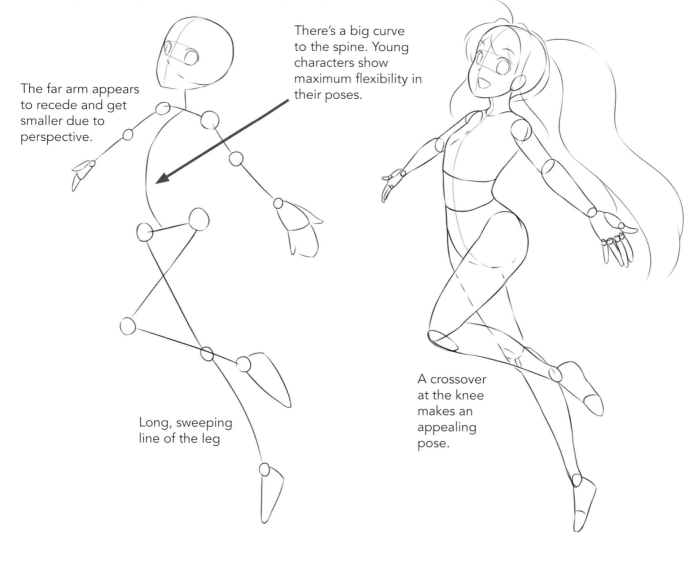

The far arm appears to recede and get smaller due to perspective.

There's a big curve to the spine. Young characters show maximum flexibility in their poses.

Long, sweeping line of the leg

A crossover at the knee makes an appealing pose.

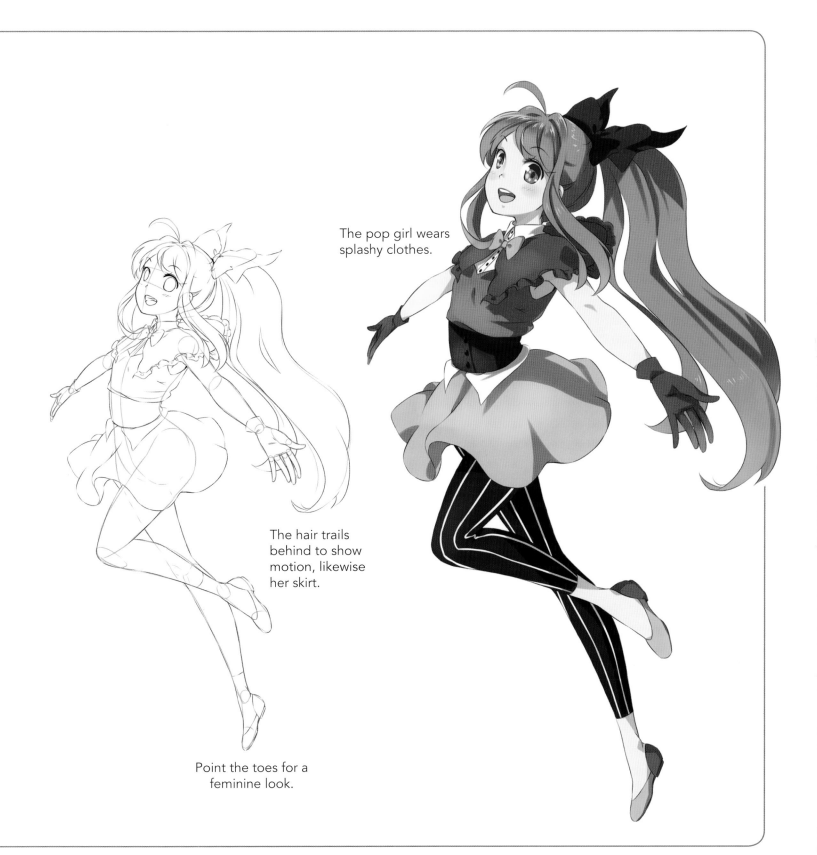

The pop girl wears splashy clothes.

The hair trails behind to show motion, likewise her skirt.

Point the toes for a feminine look.

BOY WITH FRIENDLY CREATURE

Here's another young fun-seeker. Look at that energetic pose with forward-leaning posture. A versatile character, he can do almost anything except keep his room clean. Check out his pet. When was the last time you ran into an adorable lizard? It's hard to be cute when your diet consists of flies and larvae. And yet, anime fans love these chubby reptiles. Their big eyes and smile make them irresistible.

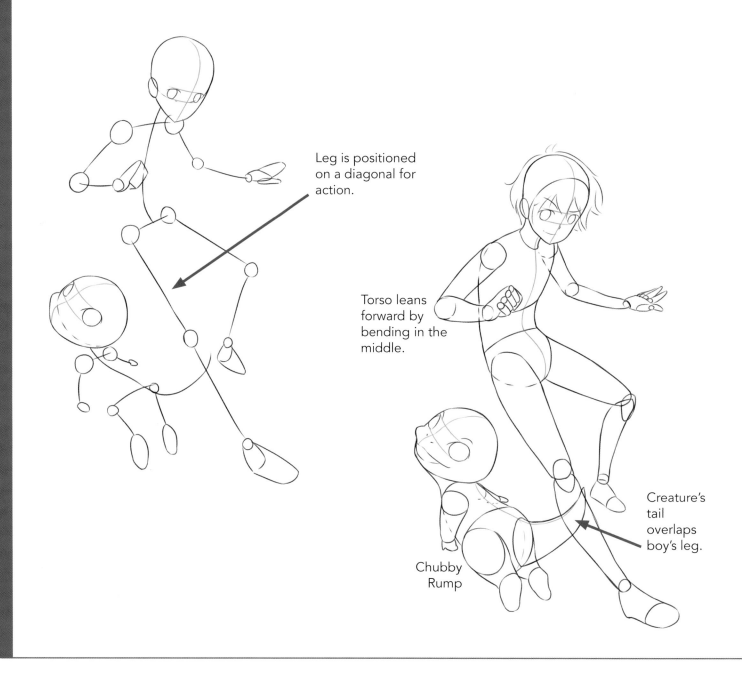

Leg is positioned on a diagonal for action.

Torso leans forward by bending in the middle.

Creature's tail overlaps boy's leg.

Chubby Rump

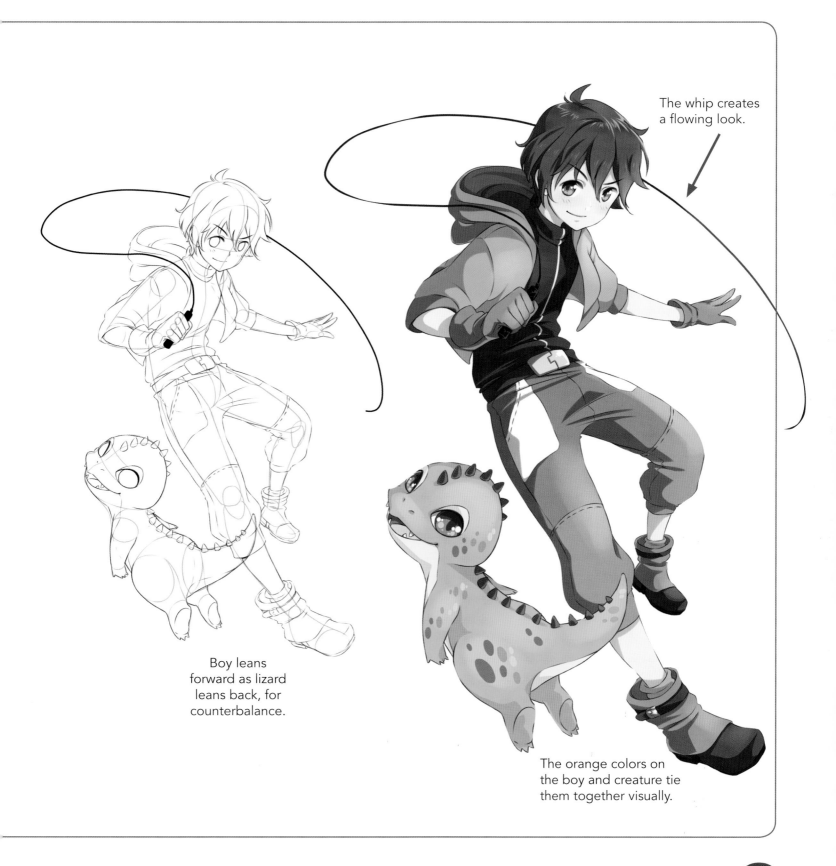

The whip creates a flowing look.

Boy leans forward as lizard leans back, for counterbalance.

The orange colors on the boy and creature tie them together visually.

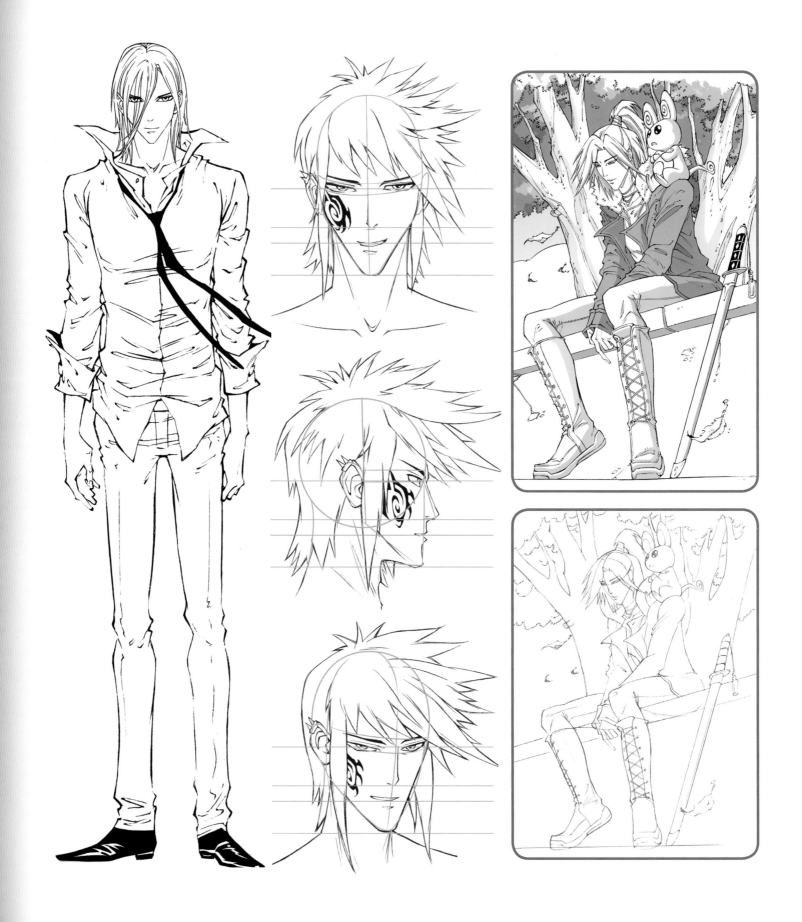

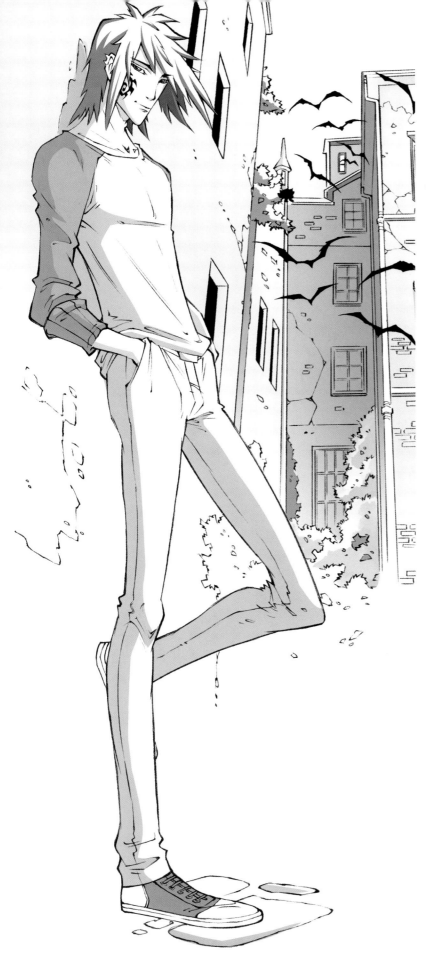

Charming Villains

Good looking, anti-social characters are everywhere in anime. They have a dangerous type of charisma and keep the story moving forward.

They may appear sensitive on the outside, but on the inside they have no feelings except for themselves. When they get into fights, they're as fierce as a sunburnt ferret with a thorn in its paw. (I kind of got stuck for a metaphor.) ■

Variations in the Villain Template

■ TYPE:
THE "HONEST" VILLAIN

This head construction can be tweaked to create numerous bad guy types. This is the first variation. He's a popular type who looks like the boy next door—if the boy next door were half a foot taller, older, broader, and with hungry eyes. Outwardly, he's polite and friendly.

Long, blond hair and a friendly smile are his hallmark traits. He's even properly dressed in a shirt and tie, which, apparently, he just had a fight in.

HEAD PROPORTIONS

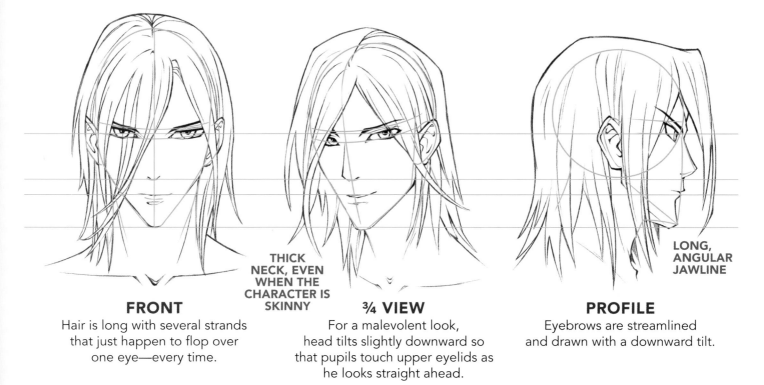

THICK NECK, EVEN WHEN THE CHARACTER IS SKINNY

LONG, ANGULAR JAWLINE

FRONT
Hair is long with several strands that just happen to flop over one eye—every time.

¾ VIEW
For a malevolent look, head tilts slightly downward so that pupils touch upper eyelids as he looks straight ahead.

PROFILE
Eyebrows are streamlined and drawn with a downward tilt.

Using Tone Instead of Color

Color images are great for conveying the total look of the character; however, color can sometimes obscure detailed line work. Therefore, this character is presented in "gray tone."

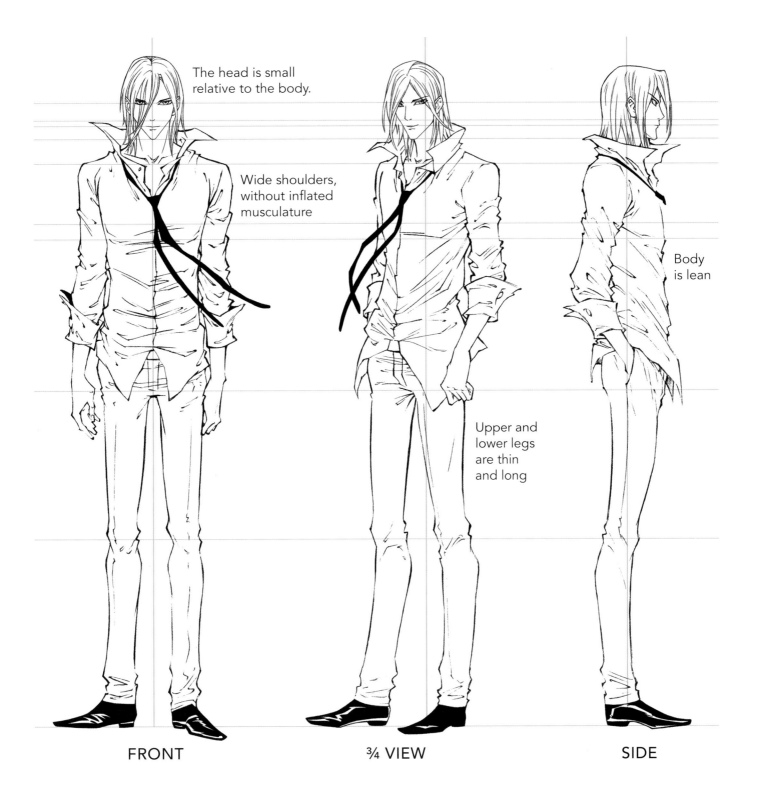

The head is small relative to the body.

Wide shoulders, without inflated musculature

Body is lean

Upper and lower legs are thin and long

FRONT

¾ VIEW

SIDE

BODY PROPORTIONS

People look up to cool characters—literally. These guys are almost always tall with a long torso and long legs. They wear fashionable clothing but are way too cool to care, so they leave it looking casual.

■ TYPE:
SAMURAI PUNK

Some people assume that simply because a guy has a cruel, predatory look in his eyes and wears a samurai haircut, it automatically labels him a bad guy. If we give in to these stereotypes, the next thing you know, people will be saying that anyone with an eye patch, scars, and spikes in their arms is also bad. Where does it end?

The basic head proportions of the samurai punk are the same as the other bad guys, except that we've tweaked the chin to be slightly narrower. Note the impact that a different hairstyle can have: it completely reinvents the character.

HEAD PROPORTIONS

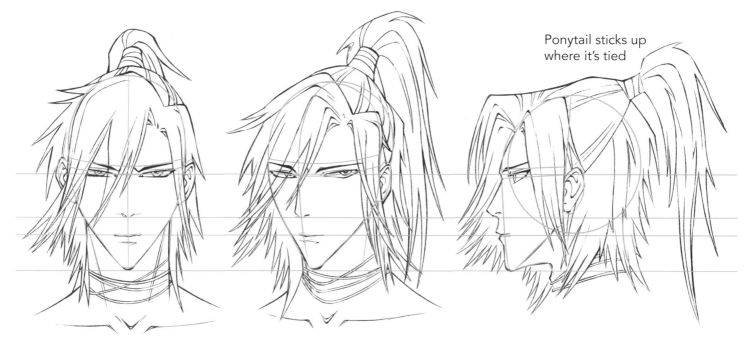

Ponytail sticks up where it's tied

FRONT
Hair has a brushed, layered look. The eyes are extremely narrow.

¾ VIEW
The jaw line is drawn at a severe angle from bottom of ear to bottom of chin, resulting in an exaggerated look.

PROFILE
In the side view, you can see the sharp line of the nose.

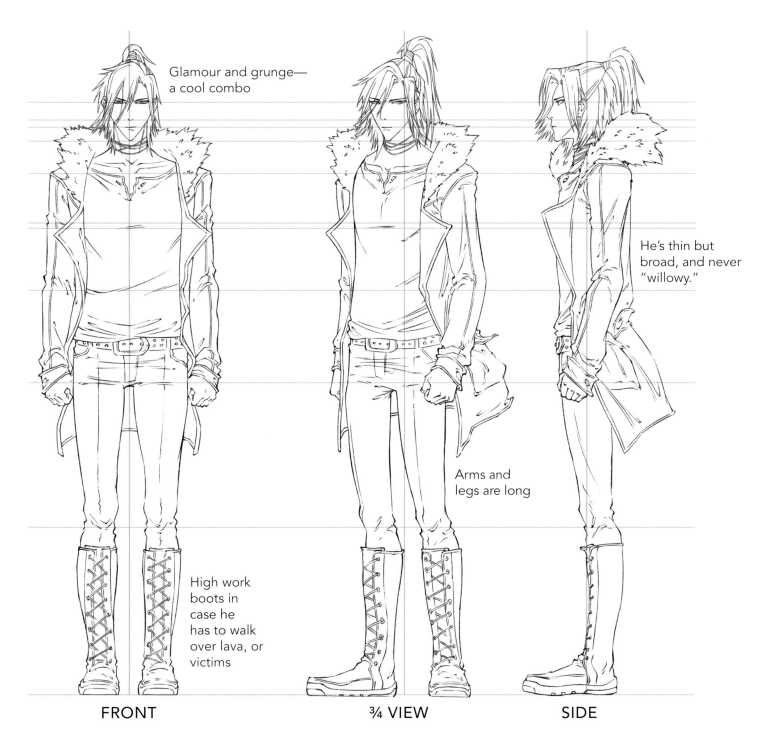

Glamour and grunge—
a cool combo

He's thin but broad, and never "willowy."

Arms and legs are long

High work boots in case he has to walk over lava, or victims

FRONT ¾ VIEW SIDE

BODY PROPORTIONS

The samurai punk likes a flashy outfit, but apparently, he also has bad taste in clothing. But I don't recommend pointing that out to him. That fur-lined jacket thing, the crude crewneck shirt, and those fashionable construction worker boots all come together to create one freaky look.

■ TYPE: WILD THING

Once again, all we need to do is change the hairstyle and add a little ink to the face, and we've created another original character: the reckless villain. A face tattoo isn't something you're likely to see on your average role model. The second giveaway is the wild hair. It should look like a porcupine fell off a tree and landed on his head.

HEAD PROPORTIONS

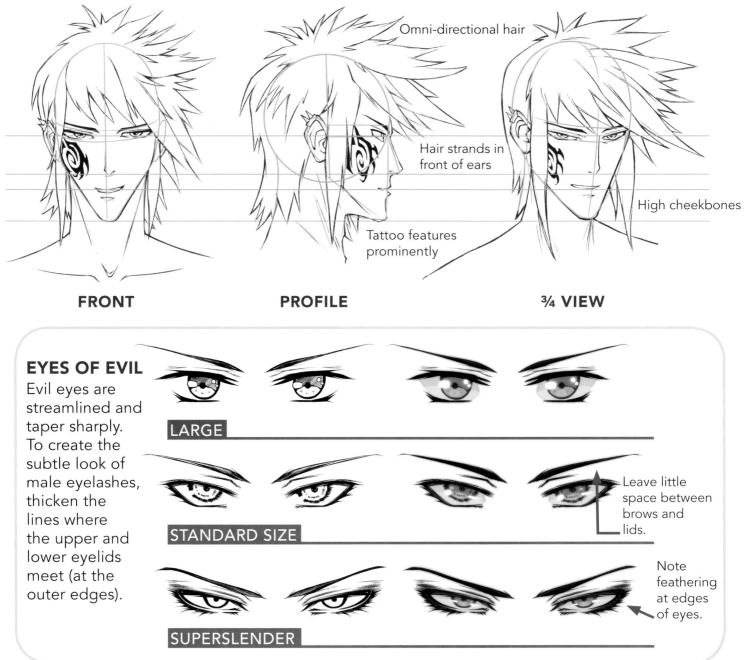

Omni-directional hair

Hair strands in front of ears

Tattoo features prominently

High cheekbones

FRONT

PROFILE

¾ VIEW

EYES OF EVIL

Evil eyes are streamlined and taper sharply. To create the subtle look of male eyelashes, thicken the lines where the upper and lower eyelids meet (at the outer edges).

LARGE

STANDARD SIZE

Leave little space between brows and lids.

SUPERSLENDER

Note feathering at edges of eyes.

86

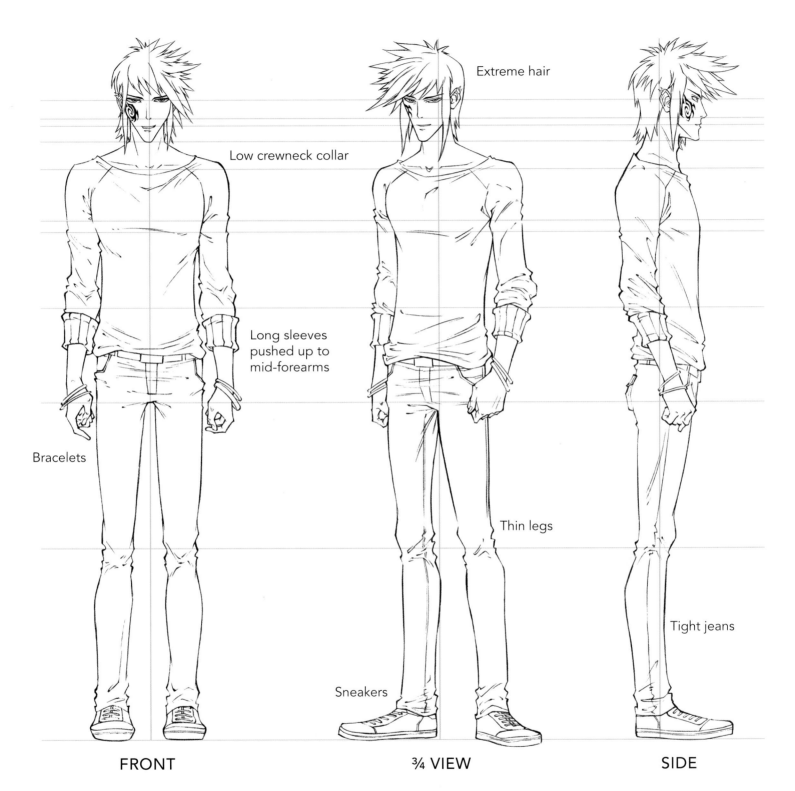

Extreme hair

Low crewneck collar

Long sleeves
pushed up to
mid-forearms

Bracelets

Thin legs

Sneakers

Tight jeans

FRONT

¾ VIEW

SIDE

BODY PROPORTIONS

Here's an interesting character-design note about drawing villians: they are
built like good guys, but their shoulders are wider and more muscular.

DRAWING EXERCISES: Vengeful Bad Guys

COOL DUDE

When you and I daydream, we think about stuff like vacations and pizza. When anime bad guys daydream, they think about revenge. There are so many ways to get even, it's so hard to decide.

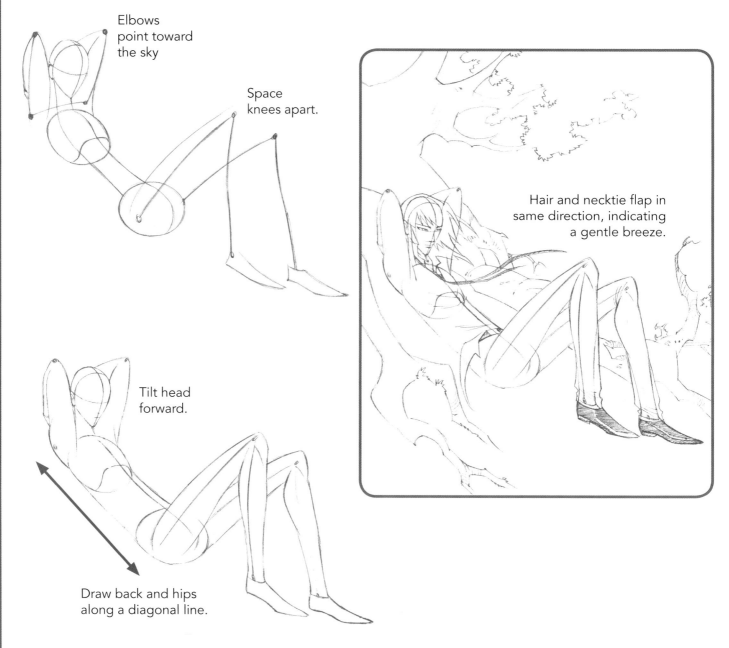

Elbows point toward the sky

Space knees apart.

Hair and necktie flap in same direction, indicating a gentle breeze.

Tilt head forward.

Draw back and hips along a diagonal line.

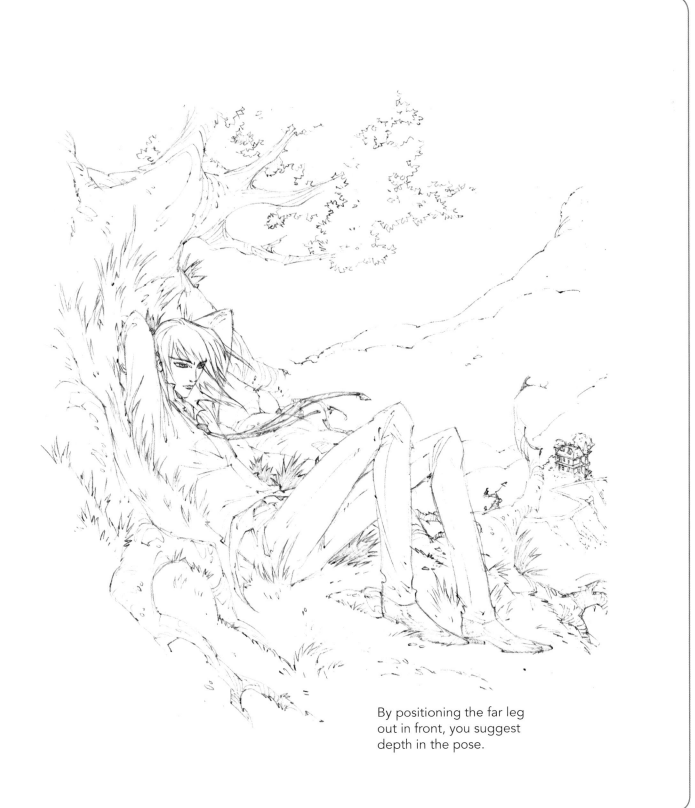

By positioning the far leg out in front, you suggest depth in the pose.

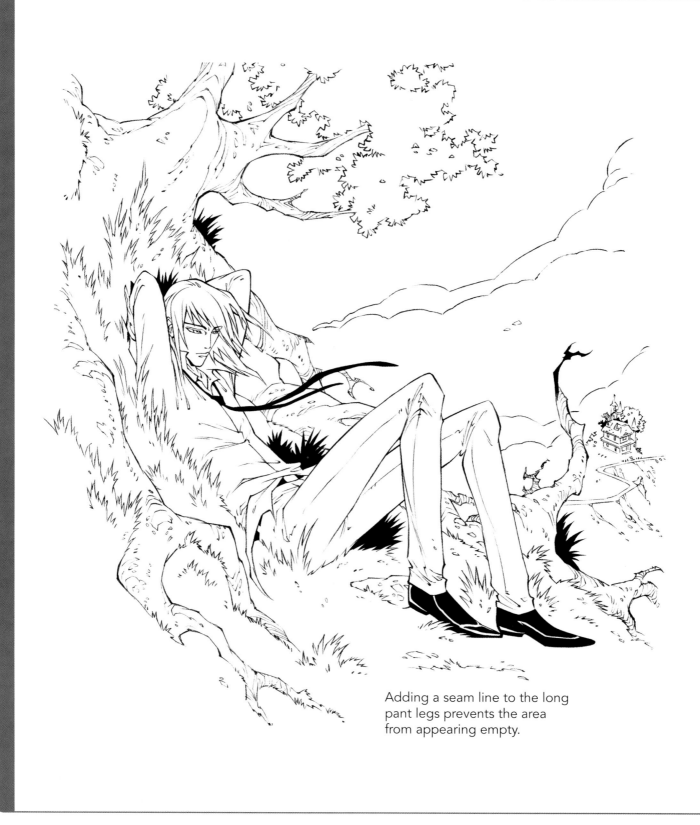

Adding a seam line to the long pant legs prevents the area from appearing empty.

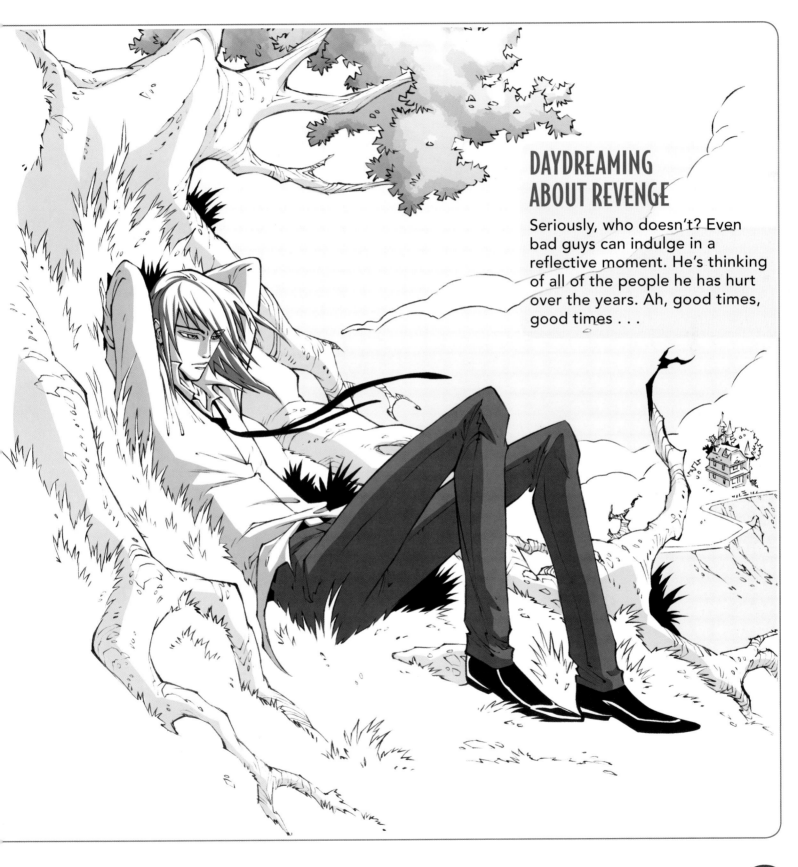

DAYDREAMING ABOUT REVENGE

Seriously, who doesn't? Even bad guys can indulge in a reflective moment. He's thinking of all of the people he has hurt over the years. Ah, good times, good times . . .

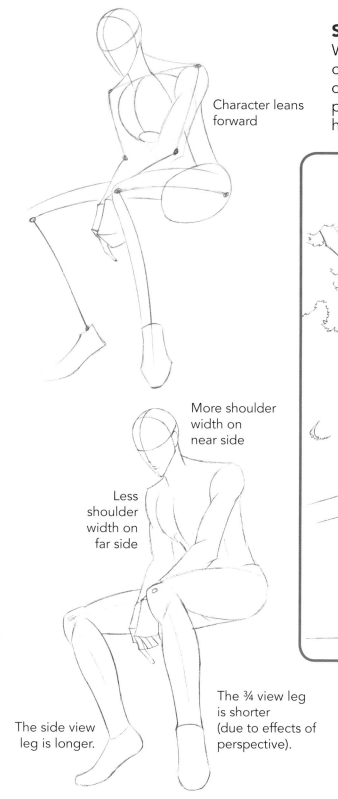

Character leans forward

SAMURAI PUNK

Why feel sorry for bad guys? Because people only fear them. No one considers their good qualities. For example, he supports his elderly parents by paying their rent from the money he's stolen. Well, it's a start.

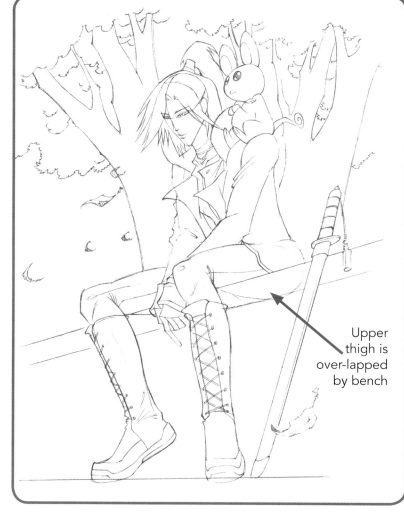

More shoulder width on near side

Less shoulder width on far side

The side view leg is longer.

The ¾ view leg is shorter (due to effects of perspective).

Upper thigh is over-lapped by bench

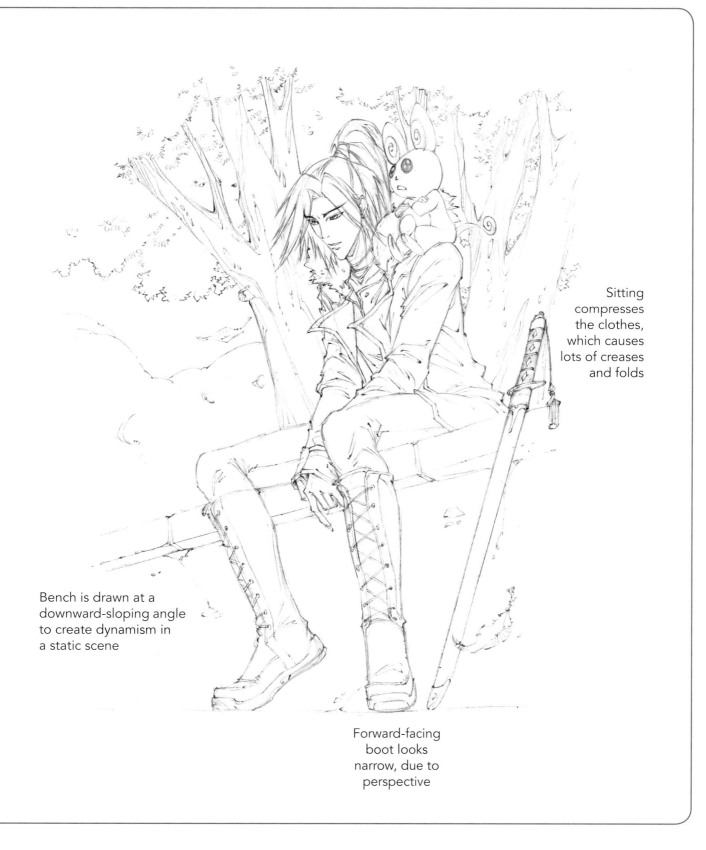

Sitting compresses the clothes, which causes lots of creases and folds

Bench is drawn at a downward-sloping angle to create dynamism in a static scene

Forward-facing boot looks narrow, due to perspective

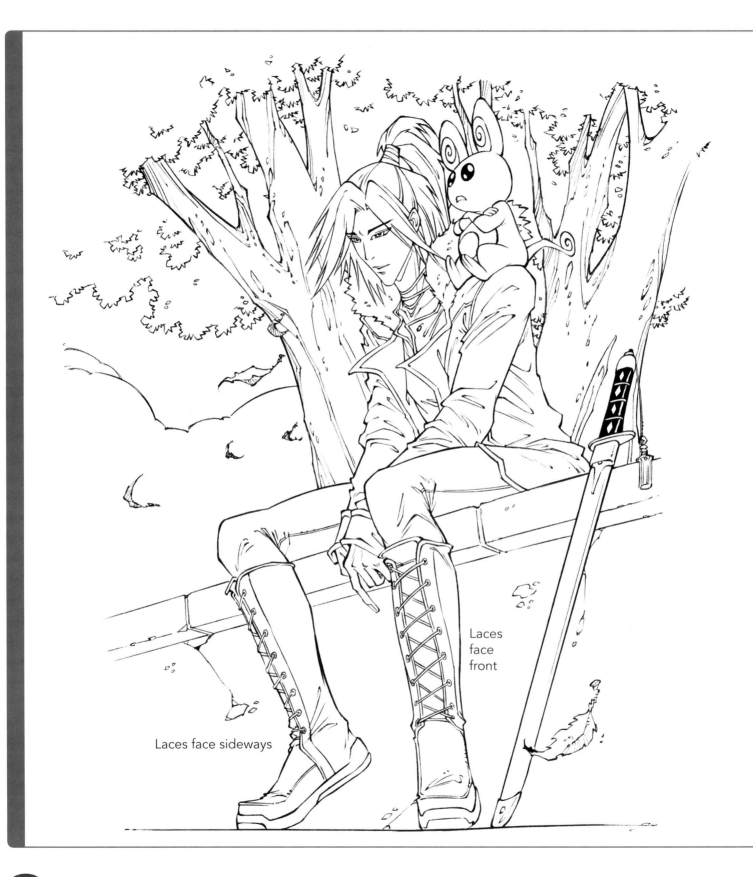

Laces face front

Laces face sideways

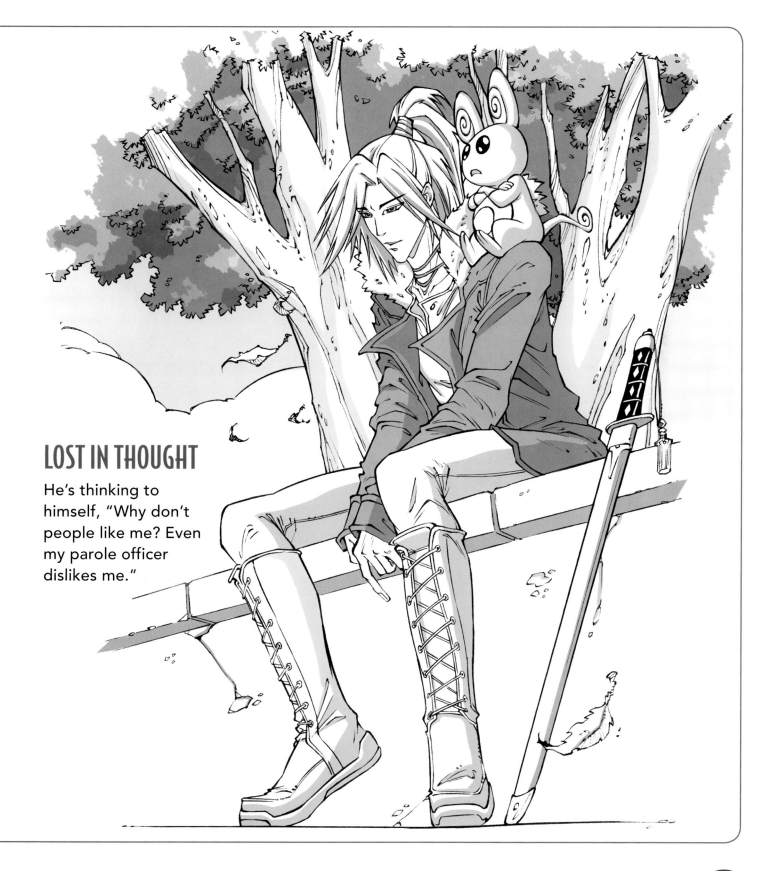

LOST IN THOUGHT

He's thinking to himself, "Why don't people like me? Even my parole officer dislikes me."

WILD THING

The bad guys of anime aren't scary-looking creeps. They're good-looking creeps. They appear normal. They fit in. This makes it very difficult to tell who is a good guy and who is bad. This adds suspense to stories featuring these characters.

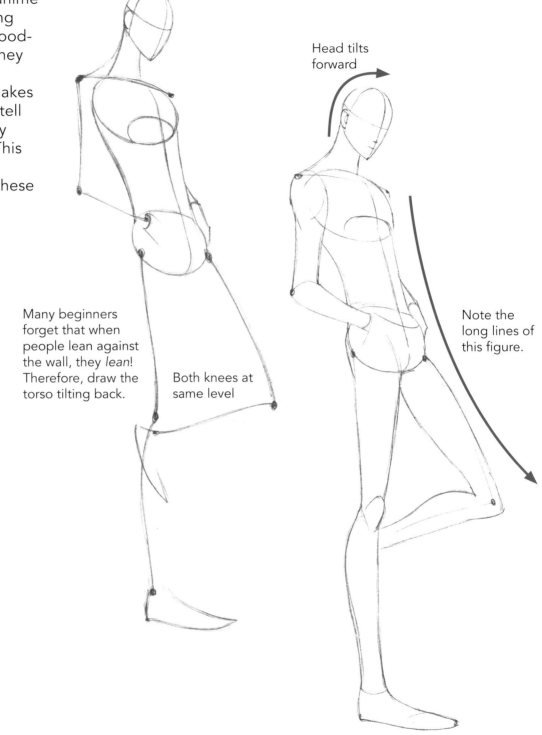

Head tilts forward

Many beginners forget that when people lean against the wall, they *lean*! Therefore, draw the torso tilting back.

Both knees at same level

Note the long lines of this figure.

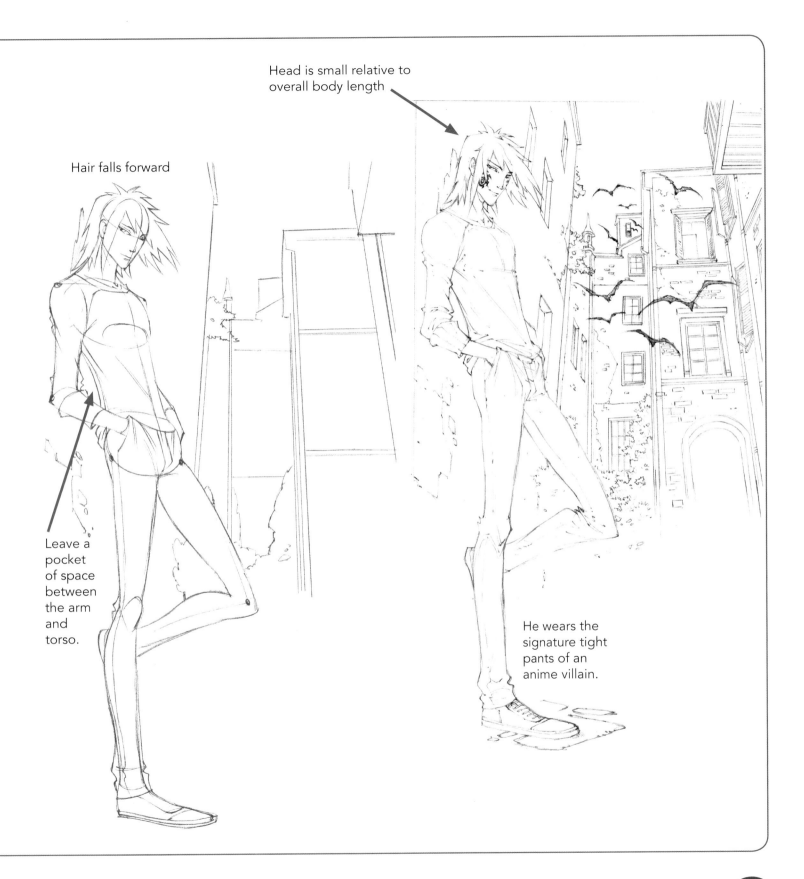

Hair falls forward

Head is small relative to overall body length

Leave a pocket of space between the arm and torso.

He wears the signature tight pants of an anime villain.

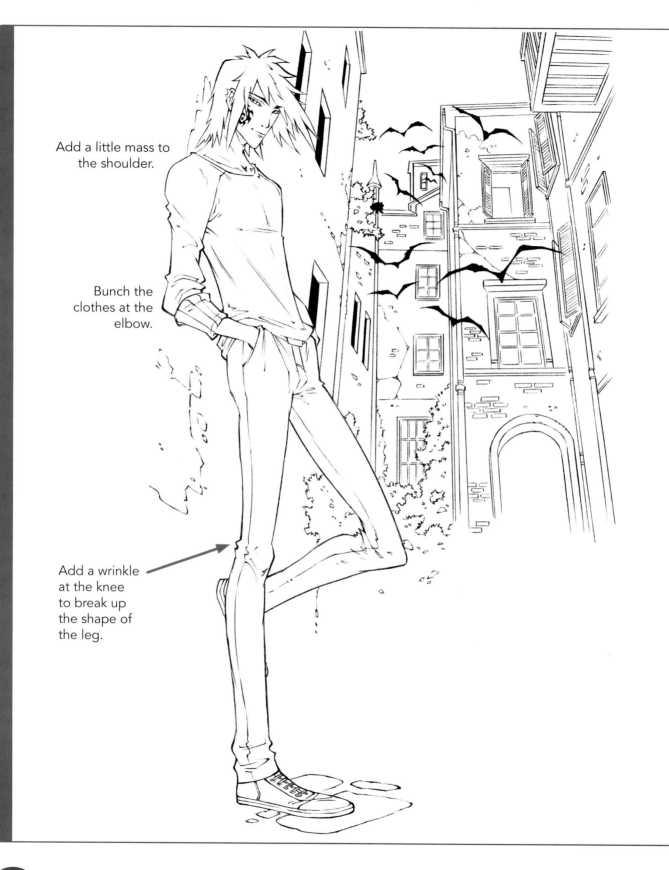

Add a little mass to the shoulder.

Bunch the clothes at the elbow.

Add a wrinkle at the knee to break up the shape of the leg.

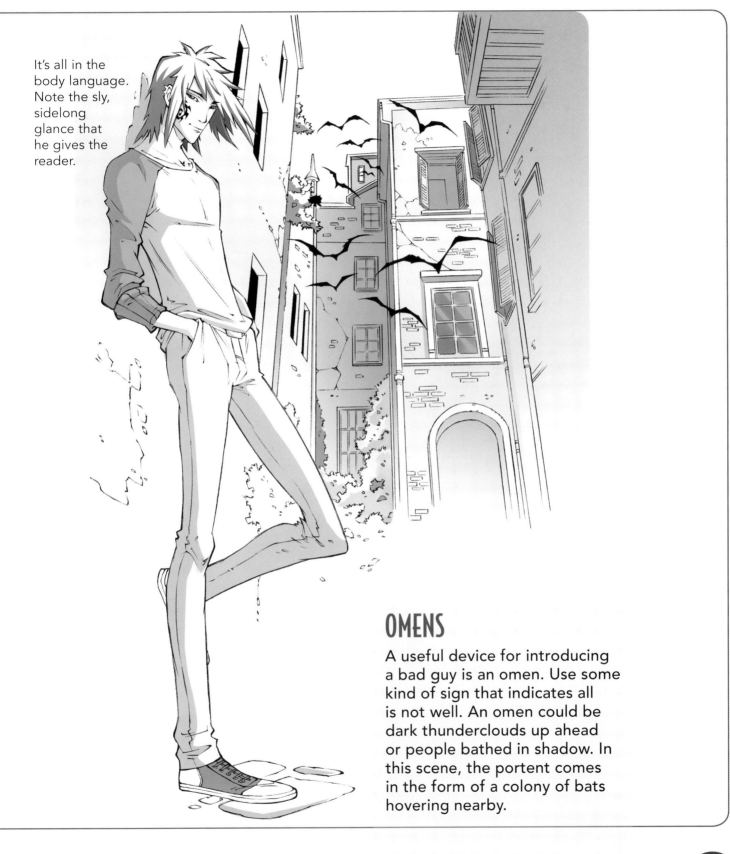

It's all in the body language. Note the sly, sidelong glance that he gives the reader.

OMENS

A useful device for introducing a bad guy is an omen. Use some kind of sign that indicates all is not well. An omen could be dark thunderclouds up ahead or people bathed in shadow. In this scene, the portent comes in the form of a colony of bats hovering nearby.

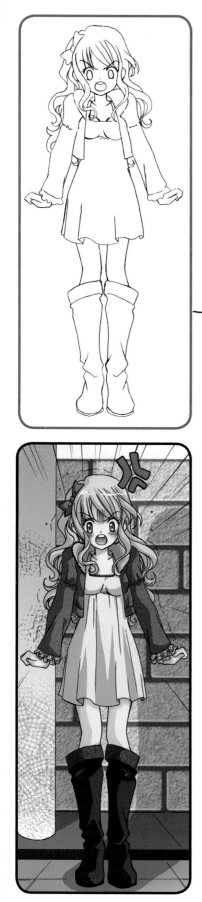
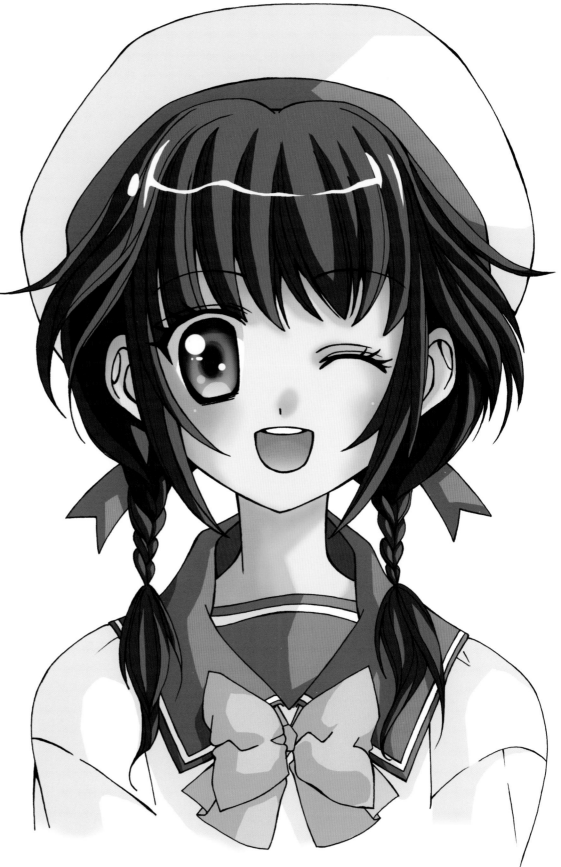

Humor in Anime

Anime is peppered with comedic characters; but how do you draw a character that is meant to be *funny*?

One effective way is to draw a character that's a little "too much" of whatever their personality trait is. For example, a perky character would be a little *too* perky. And an angry character would be a little too explosive. Also, keep the outfits simple; too much visual complexity muddles comedy. Most humorous characters are drawn with a pleasing simplicity. Let's take a look. ■

Humorous Head Proportions: The Wink

Most often, the humorous head is simple and round. The eyes are extra large, for exaggerated expressions. Be bold in your depiction of emotions using a comedy character. For example, a dramatic character wondering about something might look wistful, while a humorous character would look confused.

The famous anime wink is a popular, playful look that's a fan favorite. The winking eye isn't drawn along the same level as the bottom of the open eye, but at a level that bisects it. The wink is humorous because it breaks with the story line and brings the audience in on the joke.

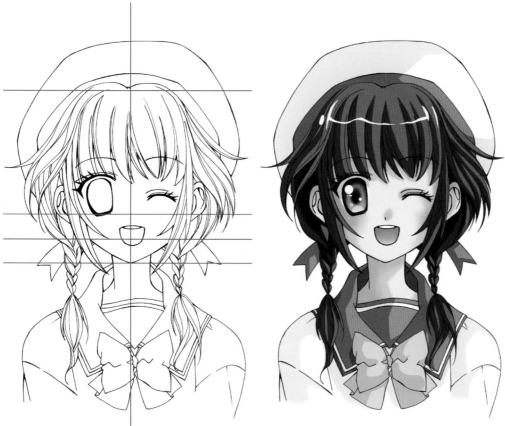

■ KEY DETAILS: FRONT

• Wide, elastic face, perfect for a host of different expressions

• Extra-large eyes

• High, arched eyebrows

• Small mouth that can "rubberize" to extremes for exaggerated expressions

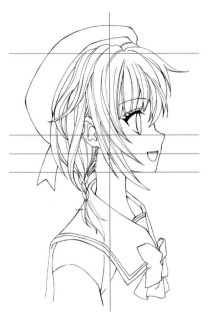
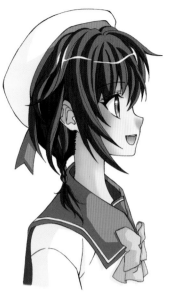

■ KEY DETAILS: PROFILE

• Although the irises of the eyes become slender in profile, be sure to maintain the length (up and down).

• Gentle slope of nose

• The outline of the face remains closed, even when the mouth is opened. This technique, widely used in manga, comes from anime. It was originally invented for practical reasons. When a character spoke, only the mouth moved on a cel overlay. However, it went on to become a signature look for manga, too.

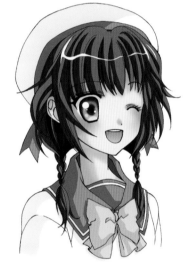

■ KEY DETAILS: ¾ VIEW

The closed eye falls at the midway point of the open eye.

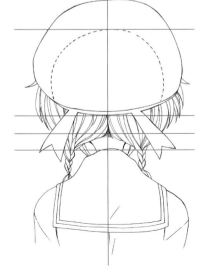
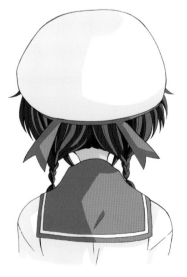

■ KEY DETAILS: BACK

• The hat adds size to the outline of the head.

• Pull the hat down in back.

• Show the back of the neck just above the collar.

Funny Body Proportions for Humorous Characters

An open expression, cute figure, and cheerful color scheme make her *fun*, not "funny looking." Humor works best when it's derived from what a character says and does. Funny reactions get laughs. A funny-looking sidekick is fine, but if you want to create an appealing

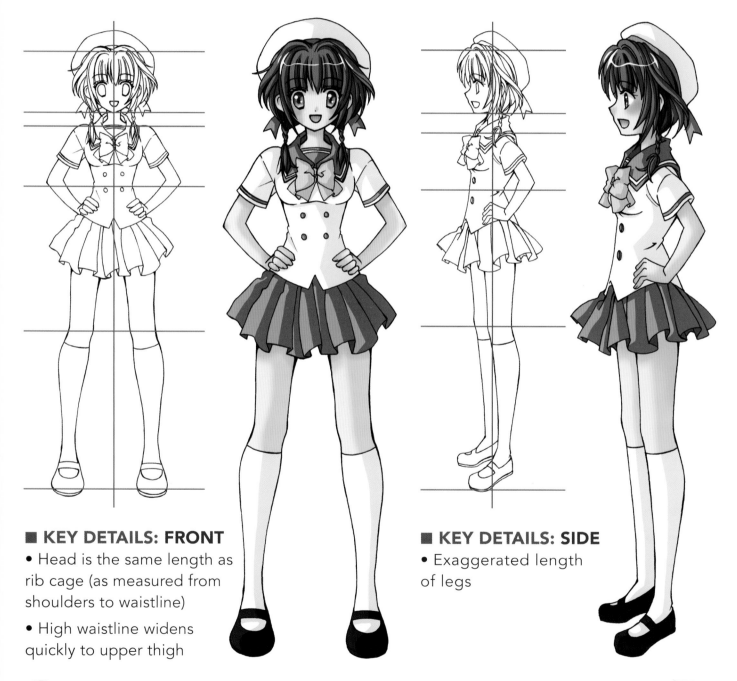

■ **KEY DETAILS: FRONT**

• Head is the same length as rib cage (as measured from shoulders to waistline)

• High waistline widens quickly to upper thigh

■ **KEY DETAILS: SIDE**

• Exaggerated length of legs

lead character, a cute look is often the better choice.

A cute outfit gives the comedic character a wholesome look. When she gets upset, and loses it, the wholesome quality creates a funny contrast.

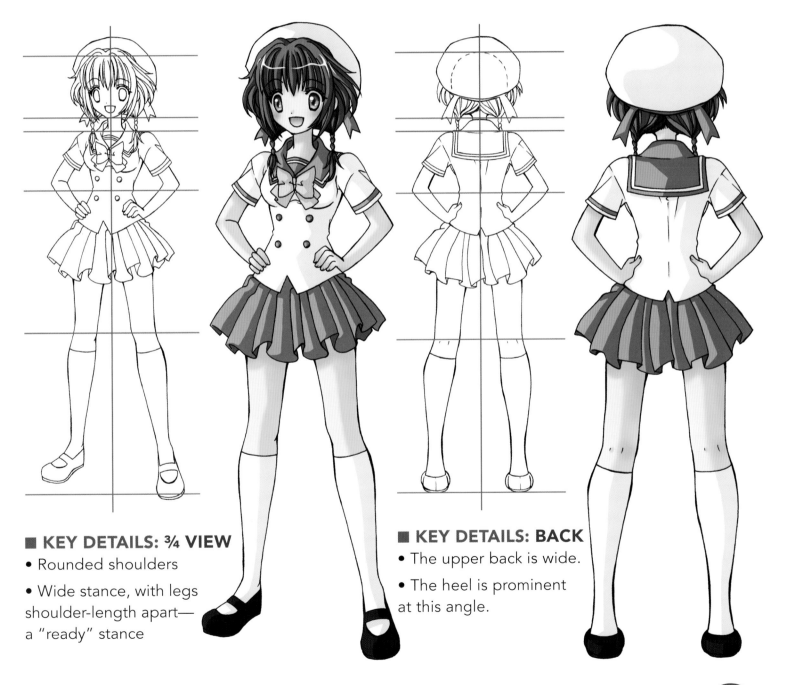

■ KEY DETAILS: ¾ VIEW
- Rounded shoulders
- Wide stance, with legs shoulder-length apart—a "ready" stance

■ KEY DETAILS: BACK
- The upper back is wide.
- The heel is prominent at this angle.

Popular Comedy Character Variations

There are many different types of comedy in anime. Although the outfits and fashions may change, the basic template for the "humorous type" remains the same. In this section, we'll create funny variations through the fashions and costumes, personality types, hairstyles, and poses. In this genre, expressions are key.

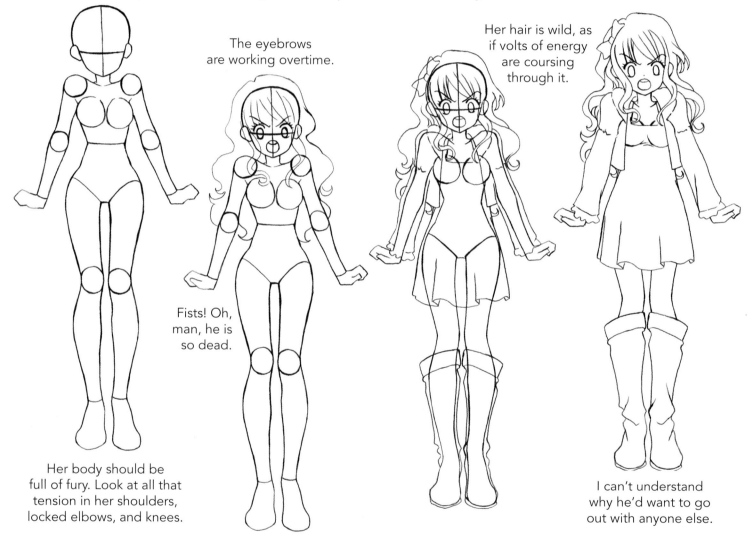

The eyebrows are working overtime.

Her hair is wild, as if volts of energy are coursing through it.

Fists! Oh, man, he is so dead.

Her body should be full of fury. Look at all that tension in her shoulders, locked elbows, and knees.

I can't understand why he'd want to go out with anyone else.

JEALOUS GIRLFRIEND
The jealous girlfriend type should be pretty—but if she were the prettiest girl on the planet, she'd have nothing to be jealous about. Therefore, it's fun to design her with slightly out-of-date hair and less-than-trendy clothing.

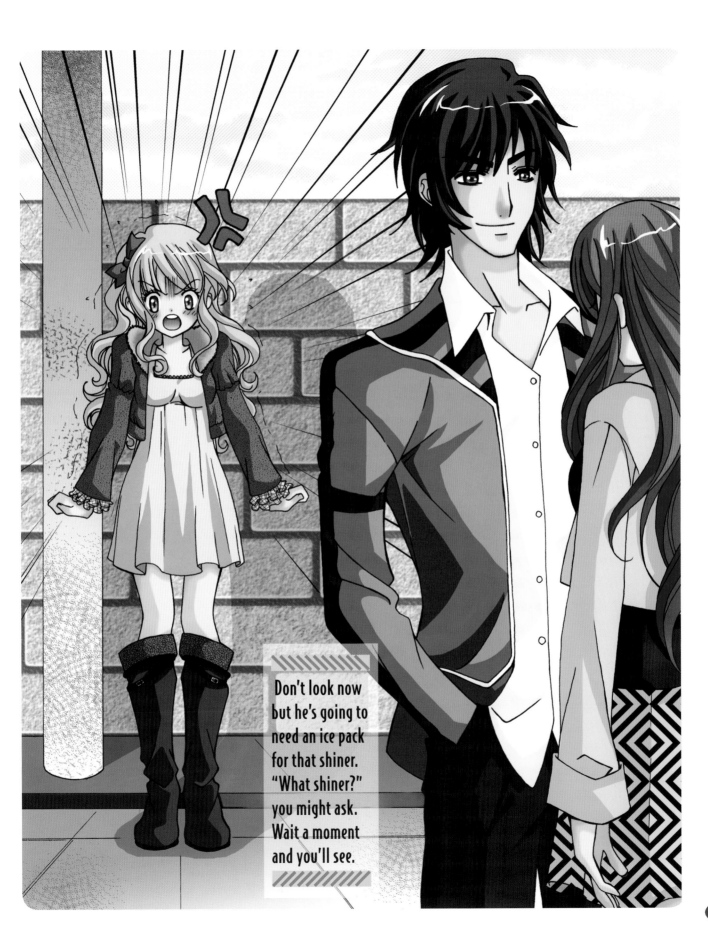

Don't look now but he's going to need an ice pack for that shiner. "What shiner?" you might ask. Wait a moment and you'll see.

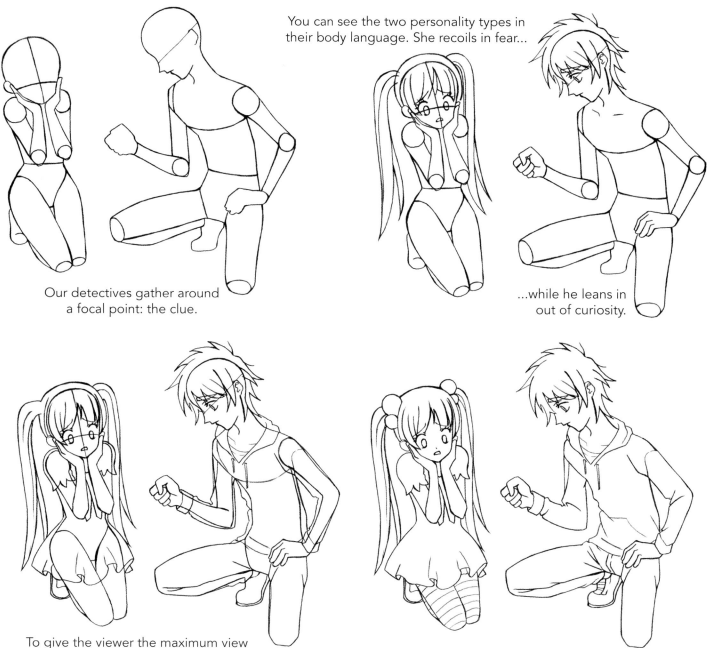

You can see the two personality types in their body language. She recoils in fear...

Our detectives gather around a focal point: the clue.

...while he leans in out of curiosity.

To give the viewer the maximum view of both characters, pose each in a ¾ view.

Casual clothing suggests that they are crime solvers by night—and high school students by day.

AMATEUR DETECTIVES

Despite the noblest of intentions, these two sleuths are utterly clueless. Sometimes, you'll see characters in mysteries wearing funny detective costumes that date back to the turn of the century. But you don't need any special costumes when your detectives are teenagers. Give them a magnifying glass and a notepad, and they're good to go.

Naturally, a creature actually big enough to make those footprints will soon appear behind the prankster.

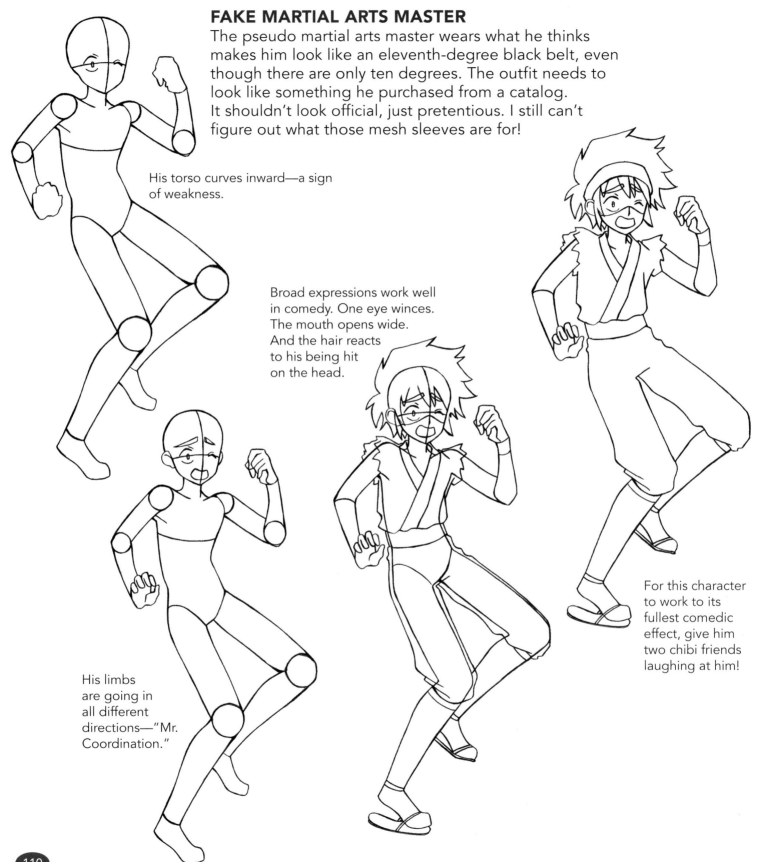

FAKE MARTIAL ARTS MASTER

The pseudo martial arts master wears what he thinks makes him look like an eleventh-degree black belt, even though there are only ten degrees. The outfit needs to look like something he purchased from a catalog. It shouldn't look official, just pretentious. I still can't figure out what those mesh sleeves are for!

His torso curves inward—a sign of weakness.

Broad expressions work well in comedy. One eye winces. The mouth opens wide. And the hair reacts to his being hit on the head.

His limbs are going in all different directions—"Mr. Coordination."

For this character to work to its fullest comedic effect, give him two chibi friends laughing at him!

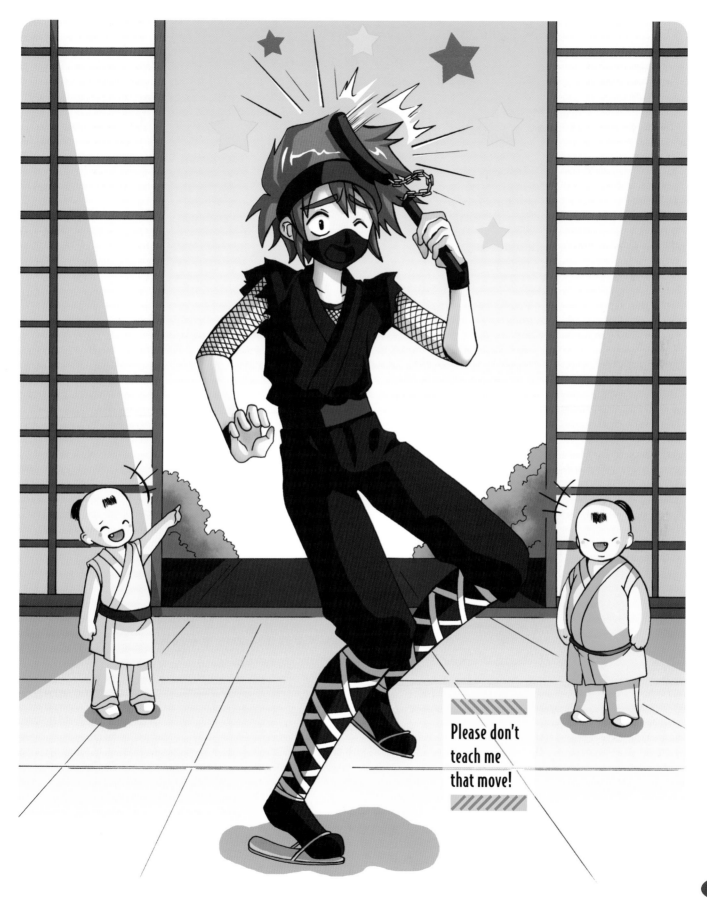

Please don't teach me that move!

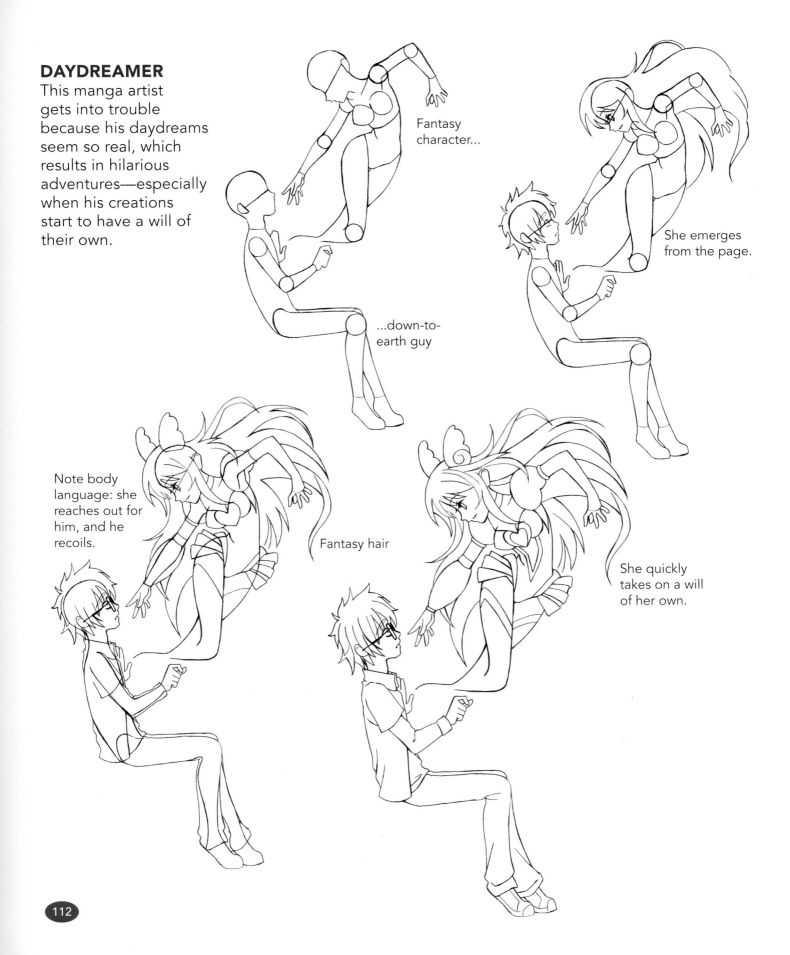

DAYDREAMER
This manga artist gets into trouble because his daydreams seem so real, which results in hilarious adventures—especially when his creations start to have a will of their own.

Fantasy character...

...down-to-earth guy

She emerges from the page.

Note body language: she reaches out for him, and he recoils.

Fantasy hair

She quickly takes on a will of her own.

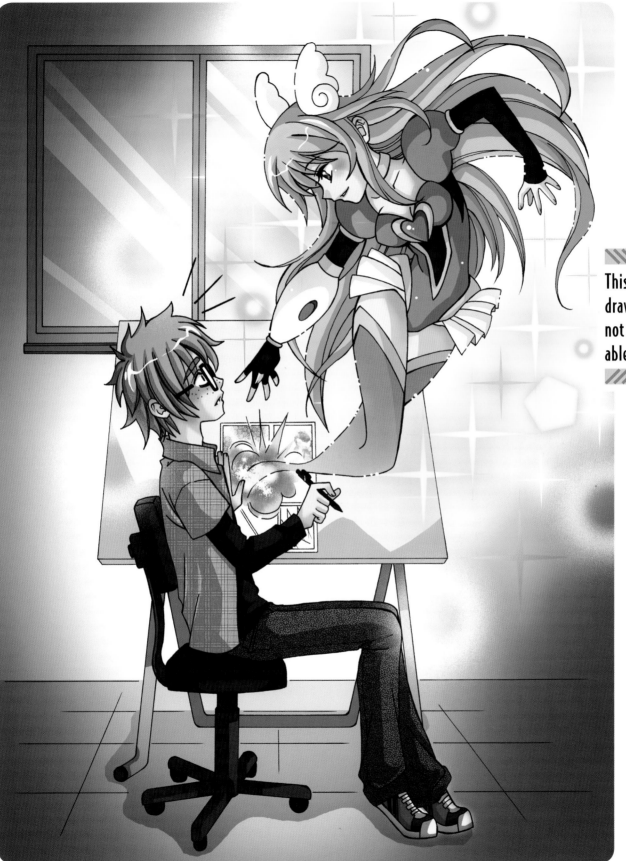

This is one drawing he's not going to be able to erase.

COSPLAYER

Cosplay stands for "costume play." Many of the attendees to anime conventions wear elaborate and highly creative costumes based on their favorite characters. Cosplayers make a great addition to the comedy genre.

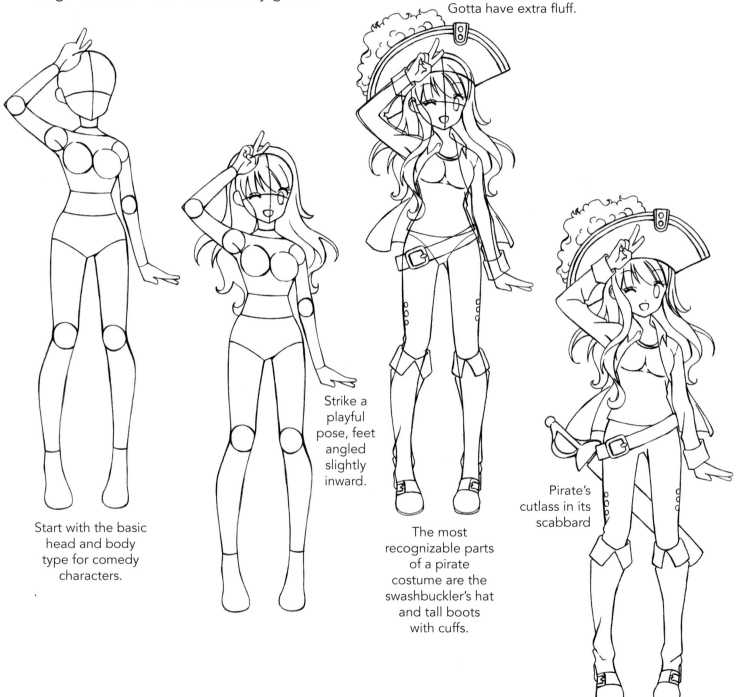

Gotta have extra fluff.

Strike a playful pose, feet angled slightly inward.

Start with the basic head and body type for comedy characters.

The most recognizable parts of a pirate costume are the swashbuckler's hat and tall boots with cuffs.

Pirate's cutlass in its scabbard

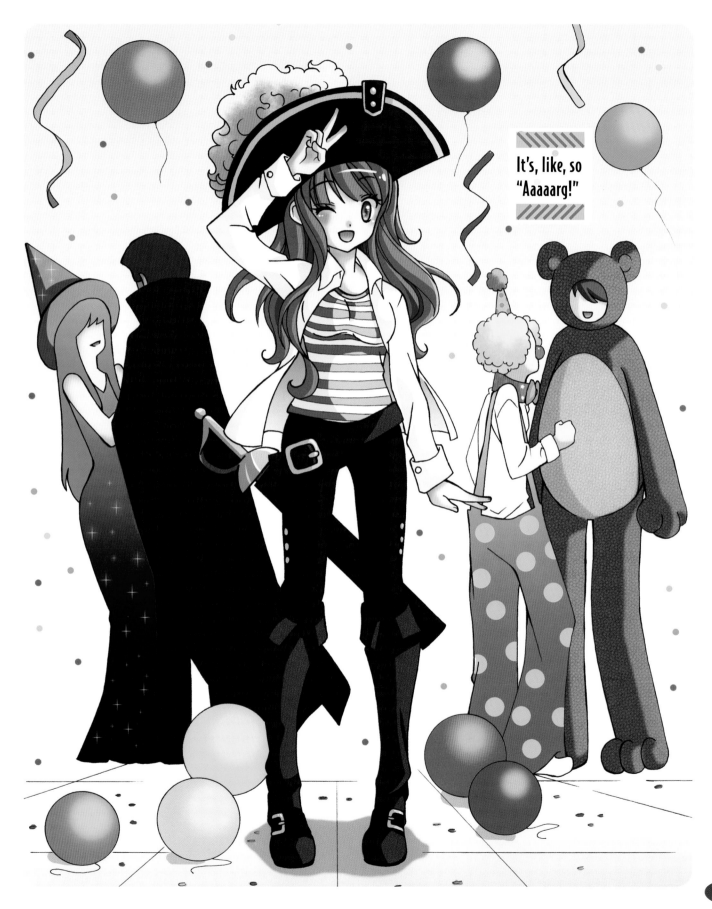

It's, like, so "Aaaaarg!"

THE WEEKEND ATHLETE

She bats lefty. Or righty. She can't remember which. But it doesn't matter, she always belts the ball for a hit but also breaks a car window in the process. Her jersey is a sweatshirt, and her cleats are basketball shoes. And get a look at those carnival stripes on her cap. The hair is roughed up a bit.

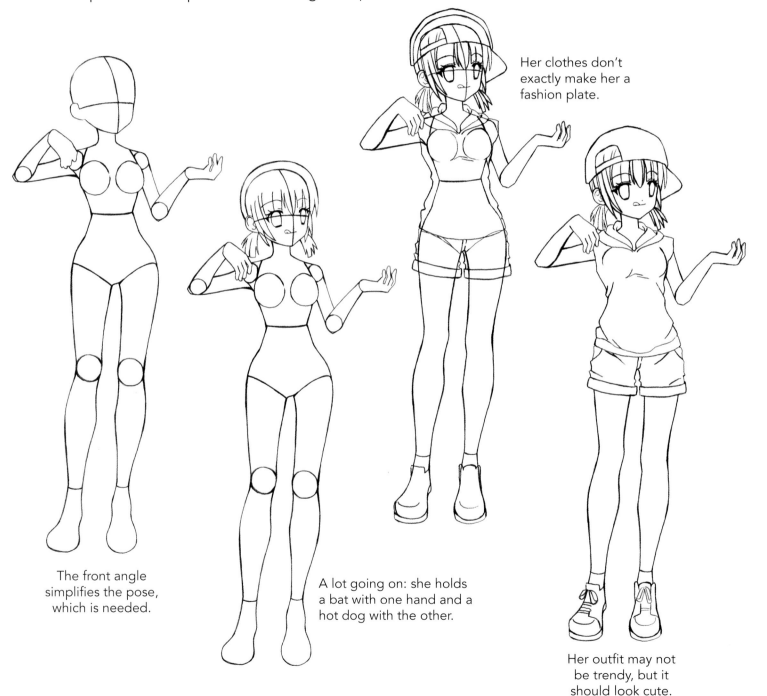

Her clothes don't exactly make her a fashion plate.

The front angle simplifies the pose, which is needed.

A lot going on: she holds a bat with one hand and a hot dog with the other.

Her outfit may not be trendy, but it should look cute.

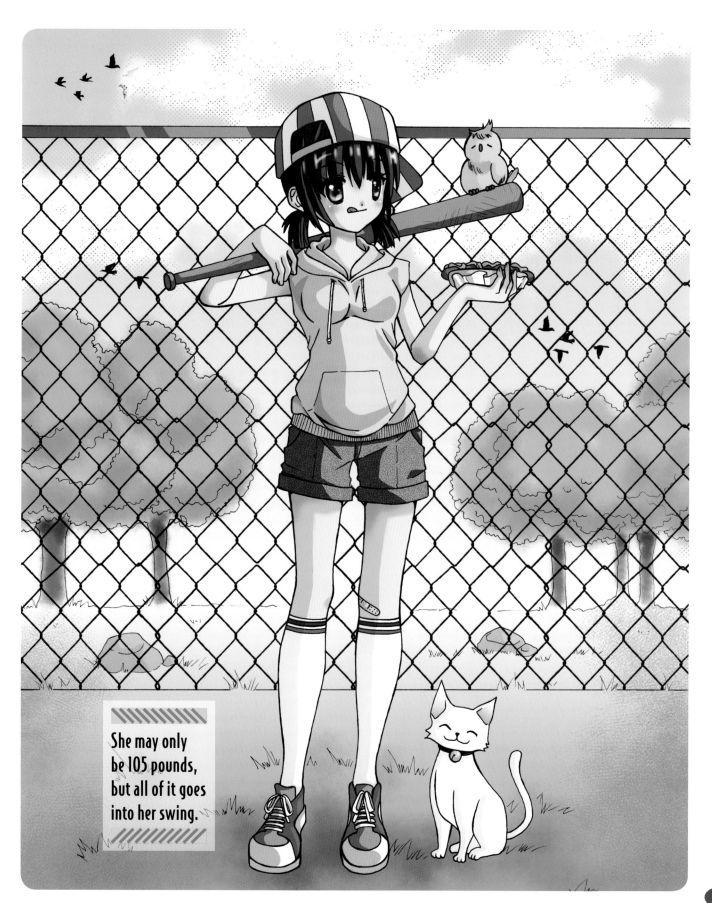

She may only
be 105 pounds,
but all of it goes
into her swing.

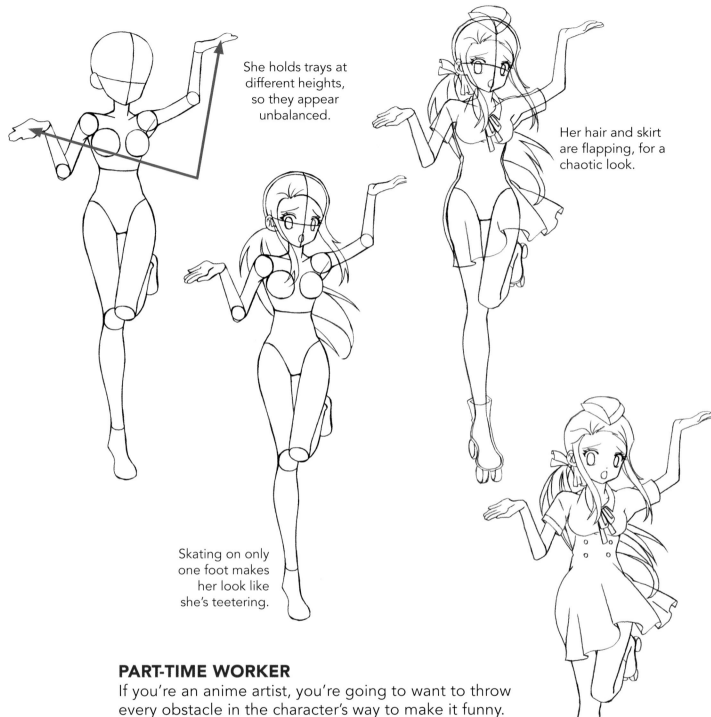

She holds trays at different heights, so they appear unbalanced.

Her hair and skirt are flapping, for a chaotic look.

Skating on only one foot makes her look like she's teetering.

PART-TIME WORKER

If you're an anime artist, you're going to want to throw every obstacle in the character's way to make it funny. She needs roller skates to get to each table fast enough to deliver the orders on time. She's learned how to skate fast. Unfortunately, she hasn't learned how to stop! Yes, the audience knows that she's going to crash, but the anticipation is most of the fun.

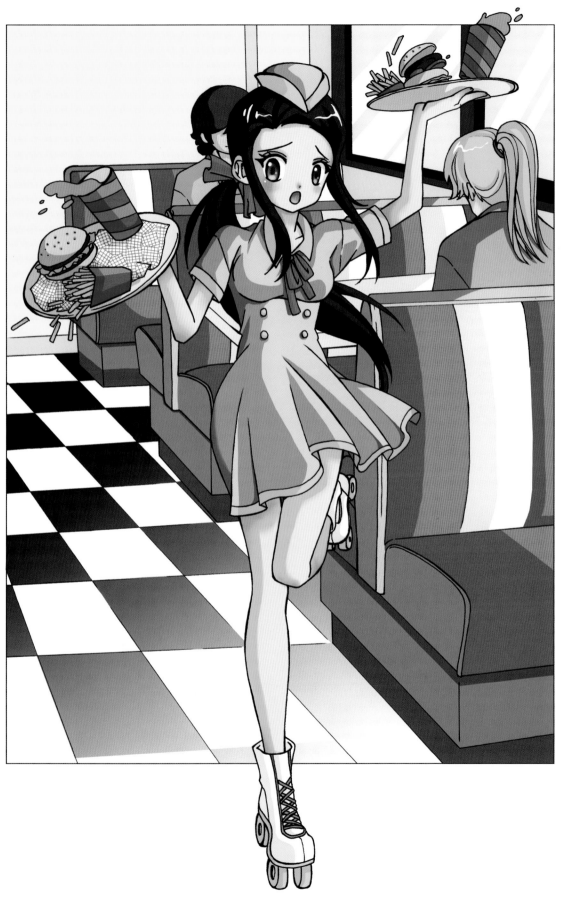

For those of you who have never seen what a flying hamburger looks like . . .

119

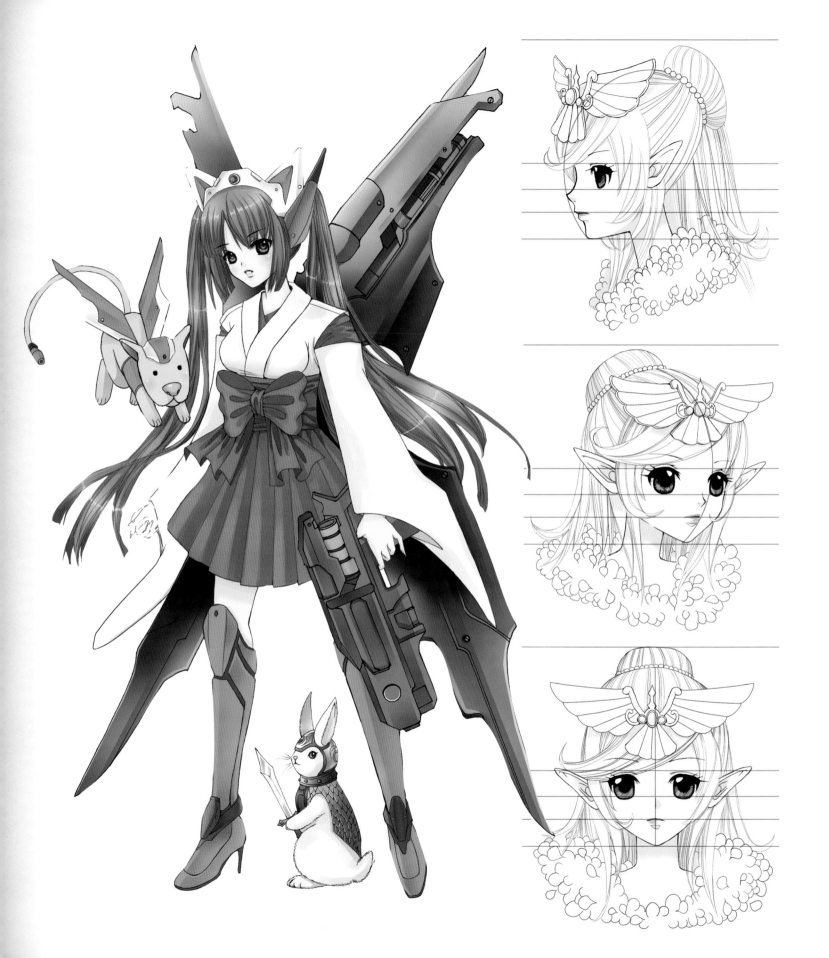

Fantasy Characters

The stunning costumes and flowing hairdos of the fantasy genre give its characters sparkling visual appeal. The template for the fantasy character type is idealized.

She is typically in her late teens or twenties. She has graceful hair, big eyes, and a tall and slender build. Her costume is elaborate and striking. She can be situated in present day, or in the future or the past. ■

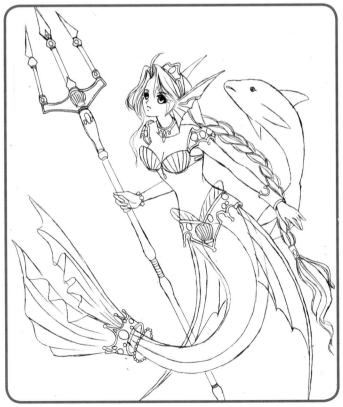

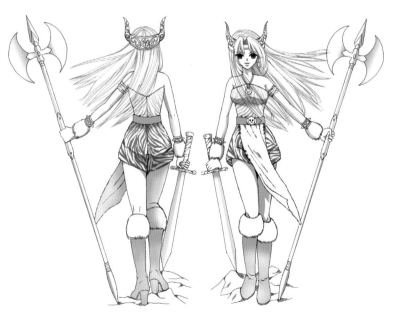

Fantasy Head Proportions 360° Template

The fantasy characters we'll be looking at all share the same basic head type. Note that the size of the hair is usually big, because fantasy is often conveyed through an elaborate hairstyle.

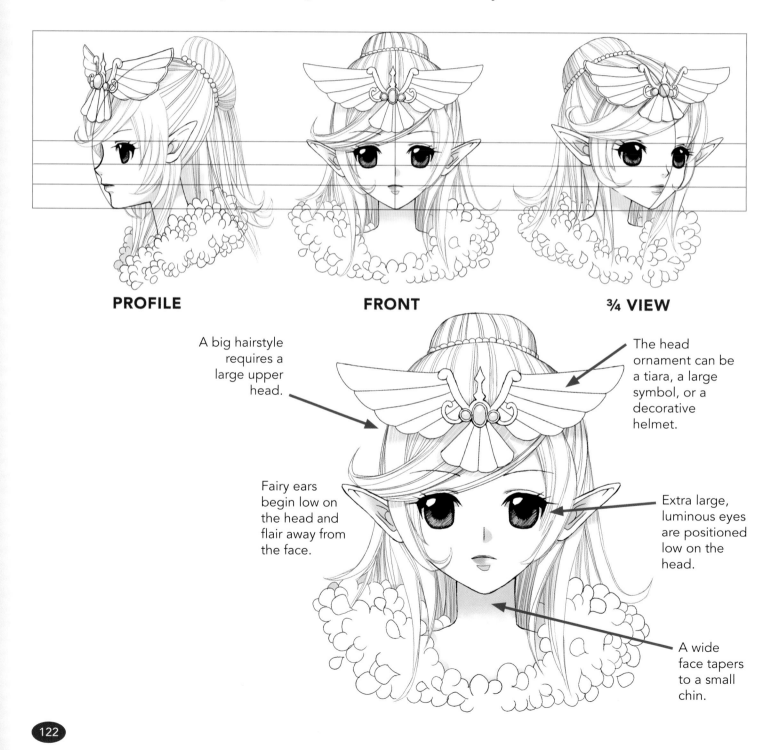

PROFILE **FRONT** **¾ VIEW**

A big hairstyle requires a large upper head.

The head ornament can be a tiara, a large symbol, or a decorative helmet.

Fairy ears begin low on the head and flair away from the face.

Extra large, luminous eyes are positioned low on the head.

A wide face tapers to a small chin.

Idealized Body Proportions

If we compare the typical 17-year-old high school girl to a typical fantasy girl character, we notice some important differences. First, not too many high schoolers have the ears of a bobcat. At least, that was true when I went to high school. But anthropomorphism aside, the main difference is that the fantasy character is longer, giving her an exaggerated look of gracefulness.

REGULAR GIRL VS. FANTASY GIRL

If the only difference between the regular girl and the fantasy girl were height, then any tall character would look like a fantasy type. But it's the *proportions* that create the real difference. The fantasy character appears idealized, which means her proportions will be elongated.

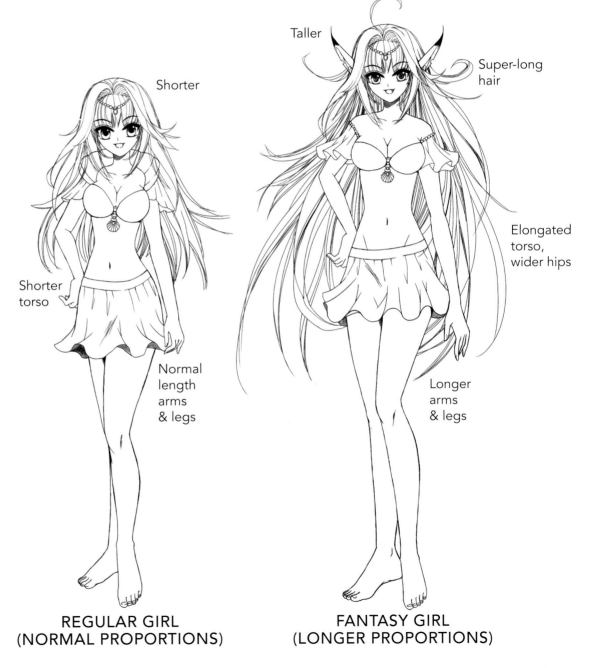

Shorter

Taller

Super-long hair

Shorter torso

Elongated torso, wider hips

Normal length arms & legs

Longer arms & legs

REGULAR GIRL
(NORMAL PROPORTIONS)

FANTASY GIRL
(LONGER PROPORTIONS)

Basic Proportions of the Heroic Pose

The fantasy figure can be tricky. So let's learn the trick. The challenge is in making her look strong and at the same time graceful. A frequently overlooked aspect of character design is a character's posture. A straight back, with the head held high, conveys a sense of power. And this warrior has it. She should look like a formidable opponent. After all, she has survived in a world filled with mythical, oftentimes savage, creatures,

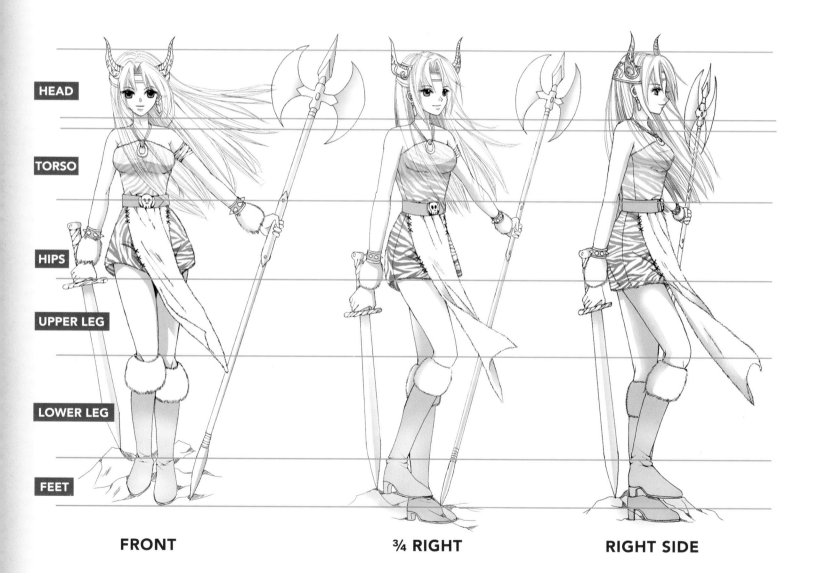

HEAD

TORSO

HIPS

UPPER LEG

LOWER LEG

FEET

FRONT　　　　　　**¾ RIGHT**　　　　　　**RIGHT SIDE**

including the most dreaded creature of them all—the personal injury attorney, which is why there's a lien against her hut.

Spend a little extra time on the weaponry in order to make it visually dramatic as well as symbolic of the fantasy world in which your character exists. This long axe can slice a monster in half. The sword can also slice a monster in half. It's not good to be a monster around her.

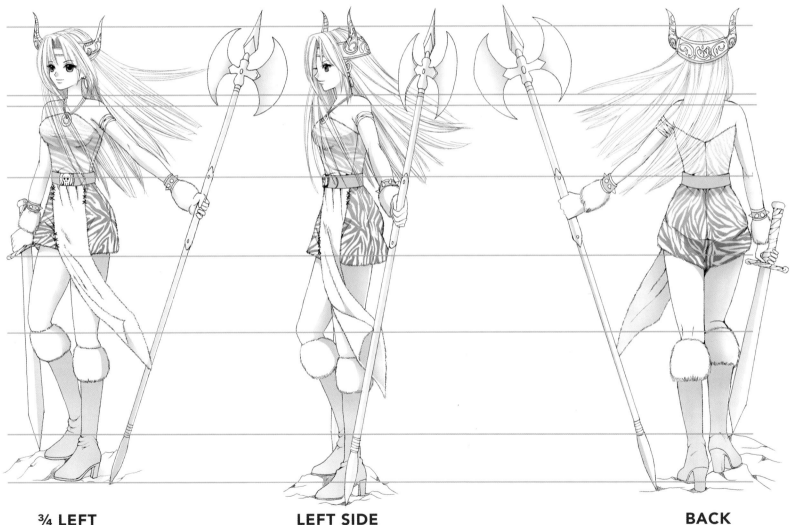

¾ LEFT **LEFT SIDE** **BACK**

Fantasy Accessories

When you think of the word *accessories*, what do you think of? If you're a fantasy character, you're probably thinking about body armor and spears.

Every item, no matter how necessary to survival, must also have a "cool" factor. Notice how ornate the armor is. This is all high-end stuff. You don't see many Buy One Pair of Forearm Armor, Get One Free sales in the Age of Darkness.

1 HEADDRESS

2 BATTLE HELMET

3 HAIR ORNAMENTS

4 NECKLACES

5 SHORT PLEATED SKIRT AND WRAP SKIRT

6 EARRINGS

7 FUR SLEEVE

8 ARMORED SLEEVE

9 BATTLE BODICE

10 SHIELD AND SWORDS

11 WARRIOR BRACELETS

12 ANKLE-WRAP SANDALS

13 LACED AND ARMORED FOOT-WEAR

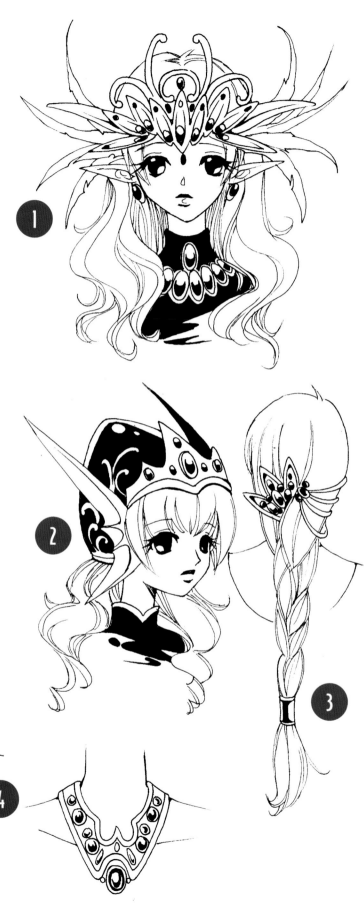

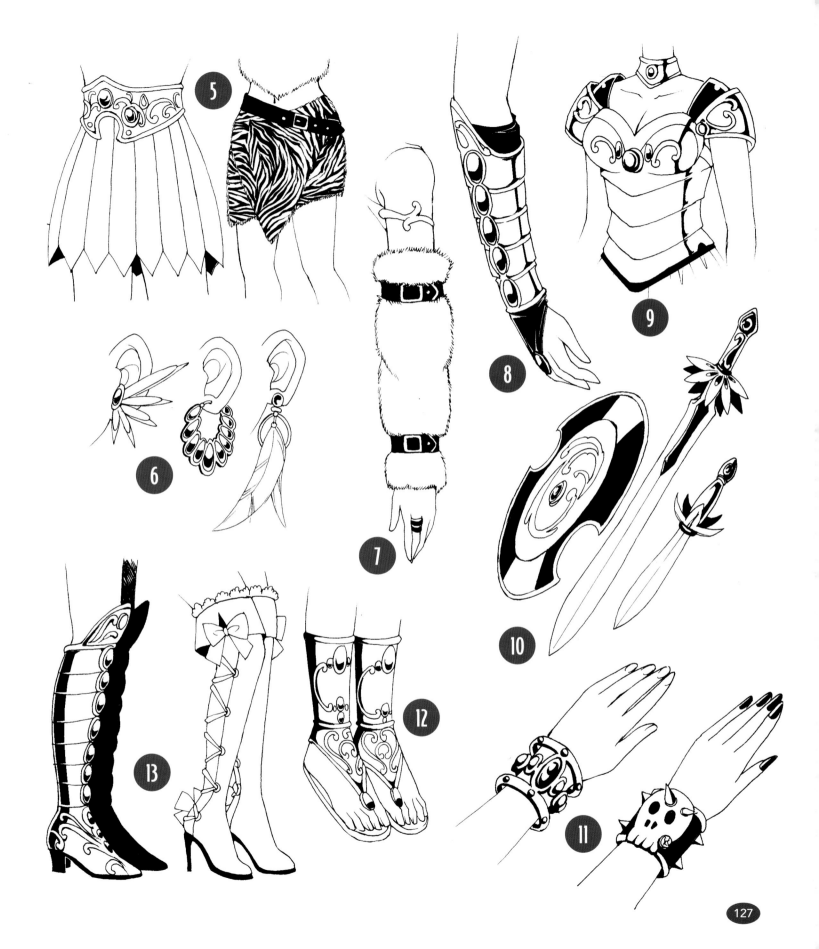

Fantasy Character Types

Costumes are all-important for creating original fantasy characters. And that's where you'll want to spend most of your creative energies. To simplify the process, begin with the standard template for fantasy bodies, and then customize the costume to create a unique character.

MIKO URBAN FIGHTER

A traditional character (often referred to as an "historical" character), fitted with mecha-style weaponry, is an eye-catching look that promises action. In this case, the character is a *miko*—a shrine maiden or priestess.

This urban fighter is created by combining contradictory themes:
• Cute and dangerous
• Traditional and futuristic
• Petite and powerful
• Cloth and metal

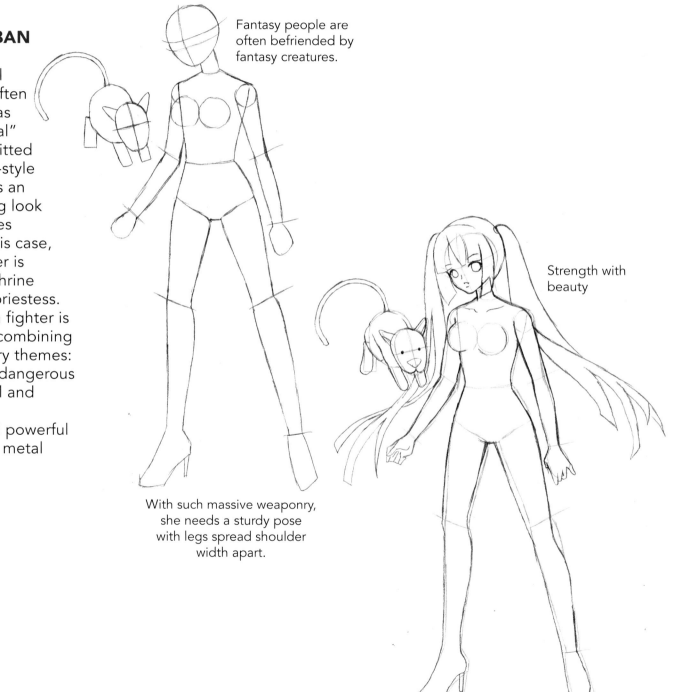

Fantasy people are often befriended by fantasy creatures.

Strength with beauty

With such massive weaponry, she needs a sturdy pose with legs spread shoulder width apart.

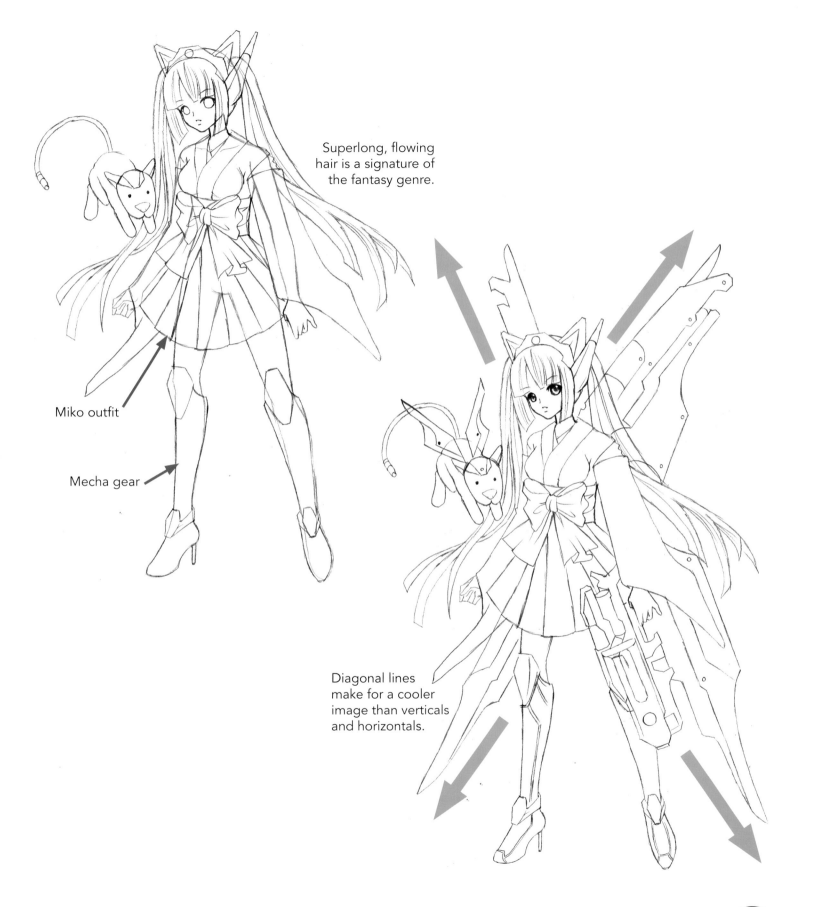

Superlong, flowing hair is a signature of the fantasy genre.

Miko outfit

Mecha gear

Diagonal lines make for a cooler image than verticals and horizontals.

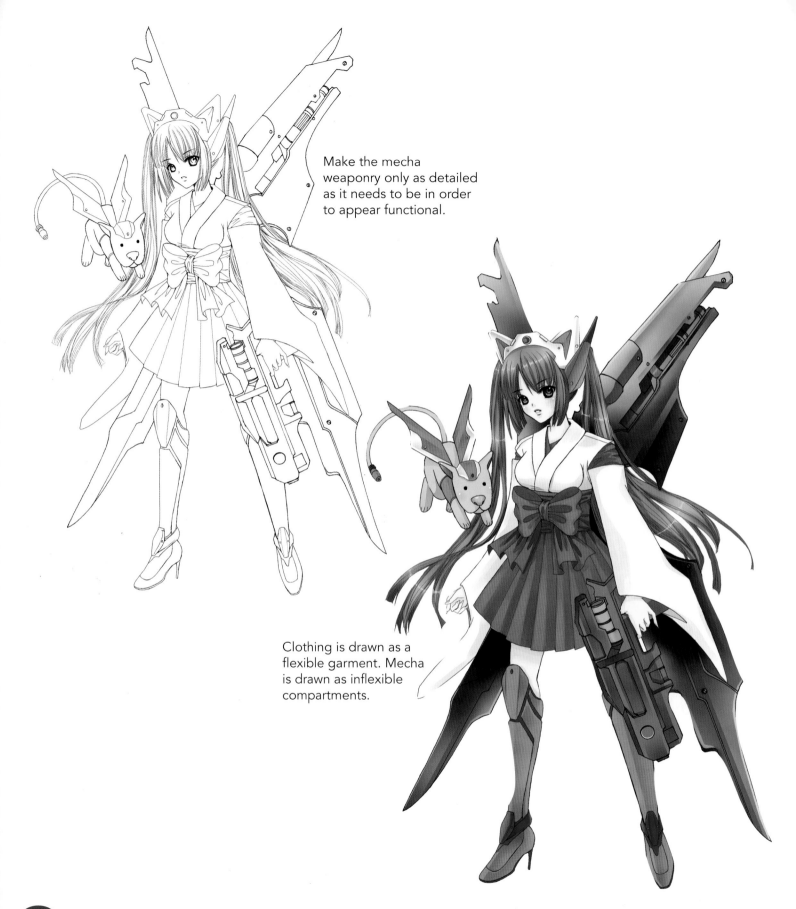

Make the mecha weaponry only as detailed as it needs to be in order to appear functional.

Clothing is drawn as a flexible garment. Mecha is drawn as inflexible compartments.

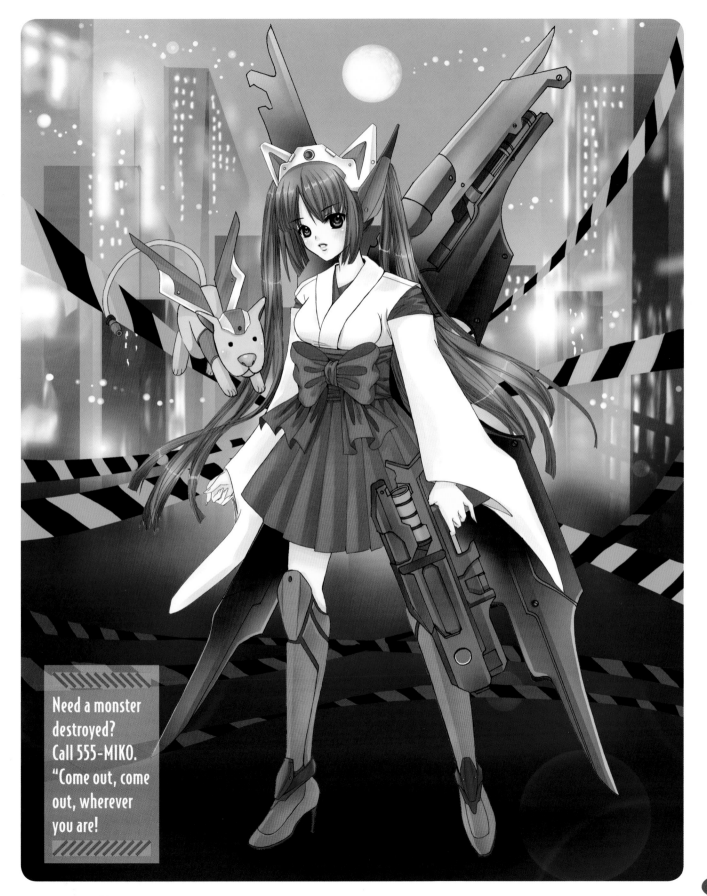

Need a monster destroyed? Call 555-MIKO. "Come out, come out, wherever you are!

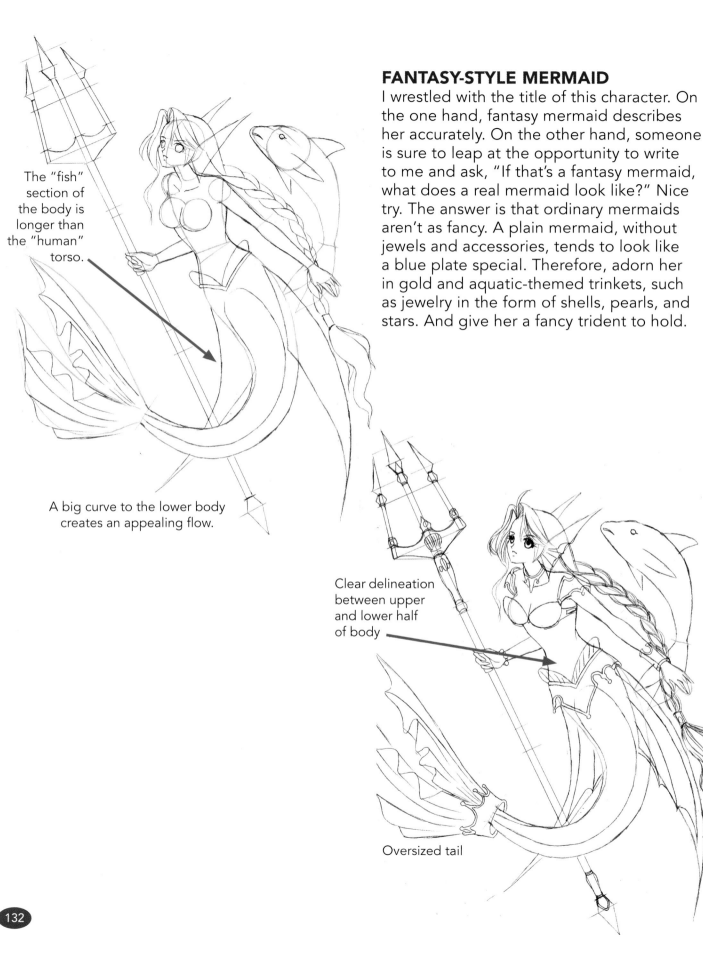

The "fish" section of the body is longer than the "human" torso.

A big curve to the lower body creates an appealing flow.

FANTASY-STYLE MERMAID

I wrestled with the title of this character. On the one hand, fantasy mermaid describes her accurately. On the other hand, someone is sure to leap at the opportunity to write to me and ask, "If that's a fantasy mermaid, what does a real mermaid look like?" Nice try. The answer is that ordinary mermaids aren't as fancy. A plain mermaid, without jewels and accessories, tends to look like a blue plate special. Therefore, adorn her in gold and aquatic-themed trinkets, such as jewelry in the form of shells, pearls, and stars. And give her a fancy trident to hold.

Clear delineation between upper and lower half of body

Oversized tail

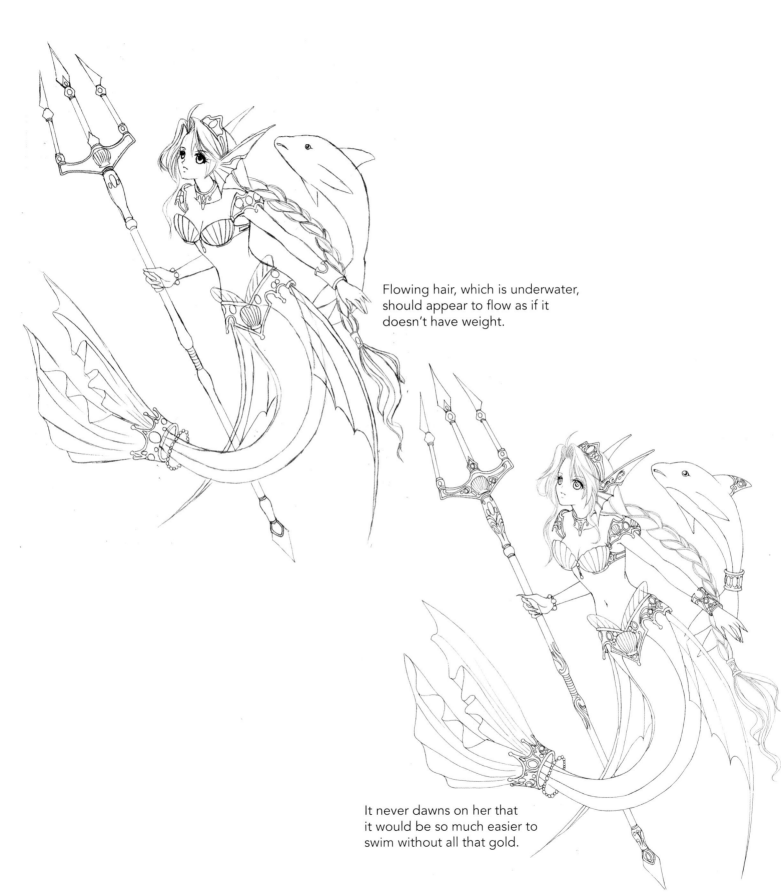

Flowing hair, which is underwater, should appear to flow as if it doesn't have weight.

It never dawns on her that it would be so much easier to swim without all that gold.

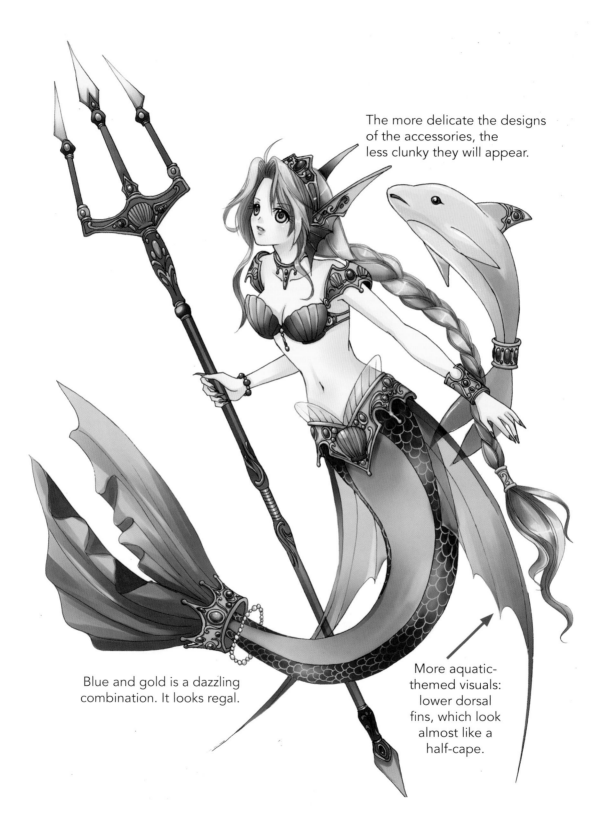

The more delicate the designs of the accessories, the less clunky they will appear.

More aquatic-themed visuals: lower dorsal fins, which look almost like a half-cape.

Blue and gold is a dazzling combination. It looks regal.

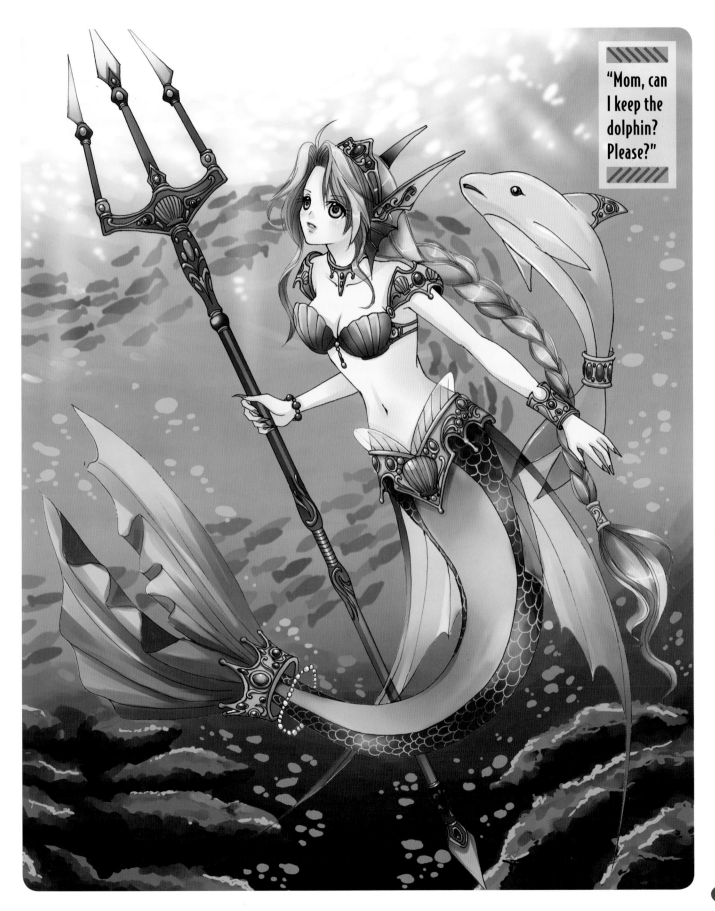

"Mom, can I keep the dolphin? Please?"

NORDIC WARRIOR

Part of the mystique of the fantasy genre derives from the ubiquitous animal-skin costumes. In Nordic environments, these rugged costumes signify the struggle against the elements. You'll notice that our fantasy warrior's animal skin doesn't come with a zipper. In fact, it looks rather chilly all opened like that. Why not at least sew some buttons on the thing and close it shut? Because then she'd be covered from head to toe in that white fuzzy coat, which would make her look like a gigantic dust bunny. The only way to create a dynamic pose is to show the pose. Ergo, open the garment.

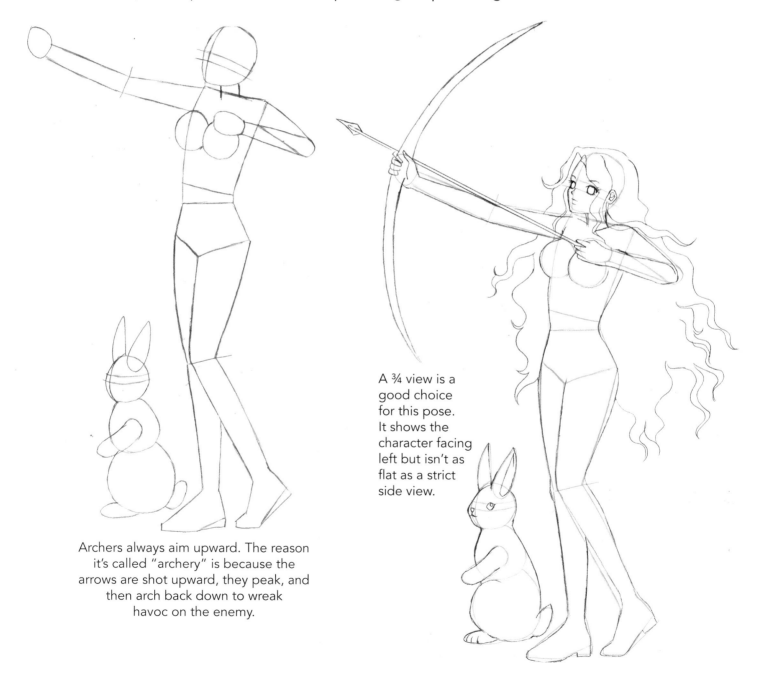

A ¾ view is a good choice for this pose. It shows the character facing left but isn't as flat as a strict side view.

Archers always aim upward. The reason it's called "archery" is because the arrows are shot upward, they peak, and then arch back down to wreak havoc on the enemy.

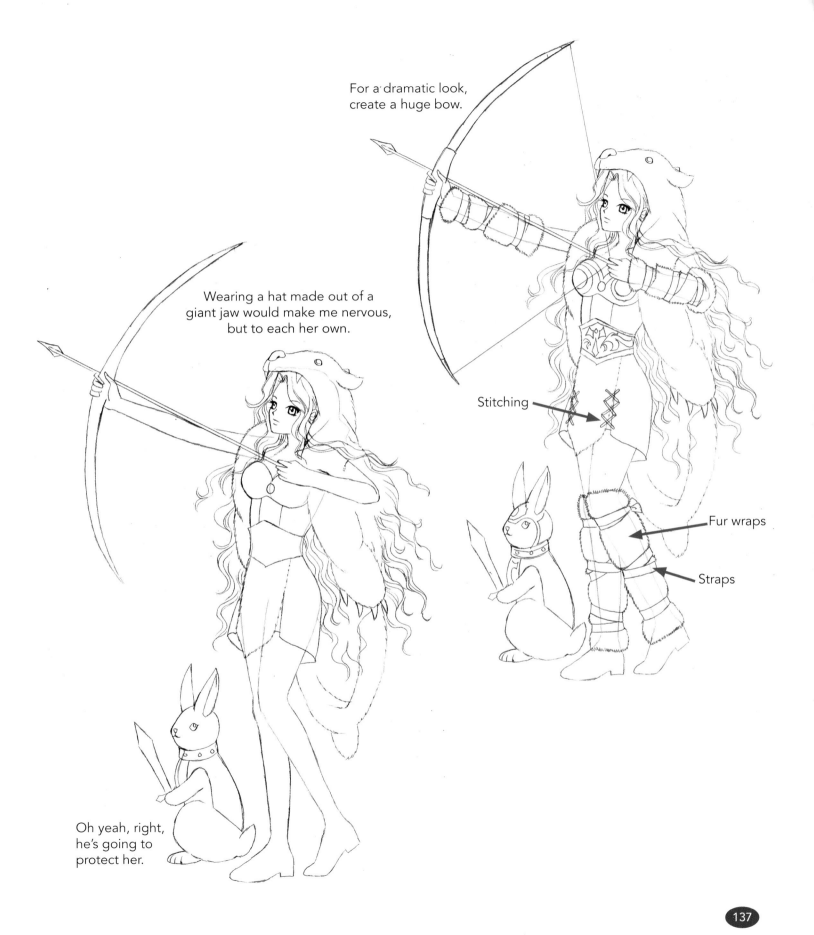

For a dramatic look, create a huge bow.

Wearing a hat made out of a giant jaw would make me nervous, but to each her own.

Stitching

Fur wraps

Straps

Oh yeah, right, he's going to protect her.

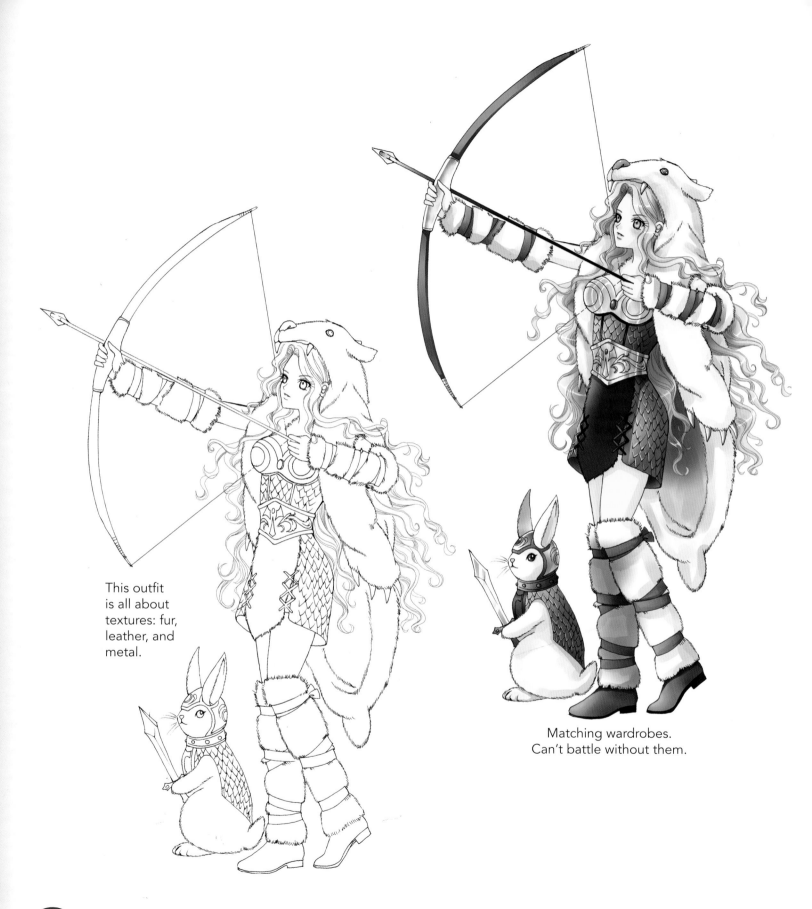

This outfit is all about textures: fur, leather, and metal.

Matching wardrobes. Can't battle without them.

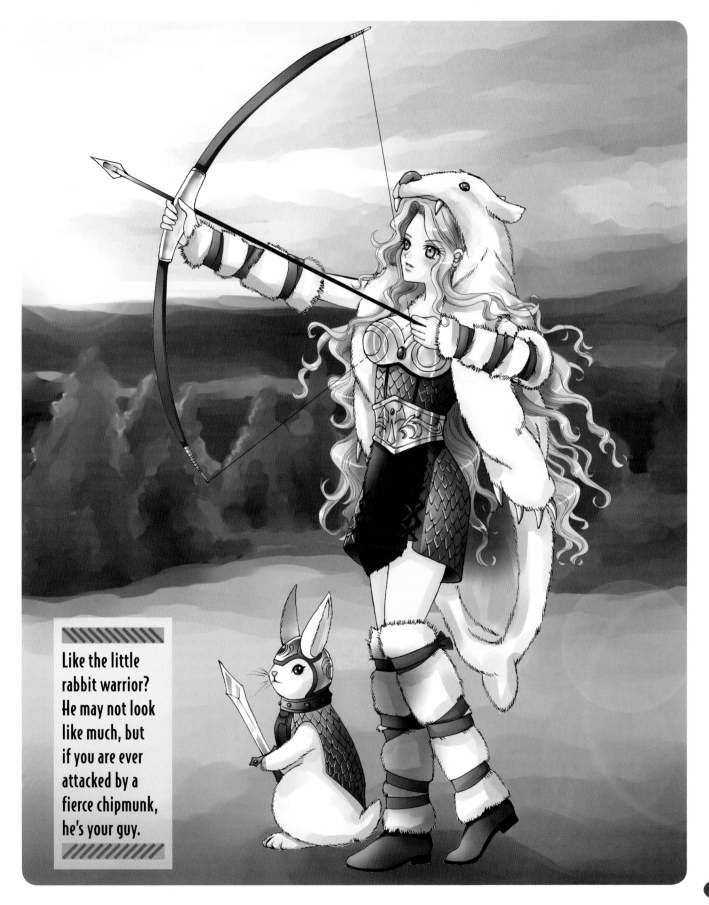

Like the little rabbit warrior? He may not look like much, but if you are ever attacked by a fierce chipmunk, he's your guy.

THE HUMAN SACRIFICE

Next time you think you're having a bad day, think about how she feels. Rituals involving human sacrifices happen all the time in the fantasy genre. It creates the most dramatic time squeeze. A "time squeeze" is a plot device, whereby you've got a limited amount of time before dire consequences happen. If she doesn't free herself before the guys with the fancy hats arrive, she's toast. Or, to be more accurate, a kabob.

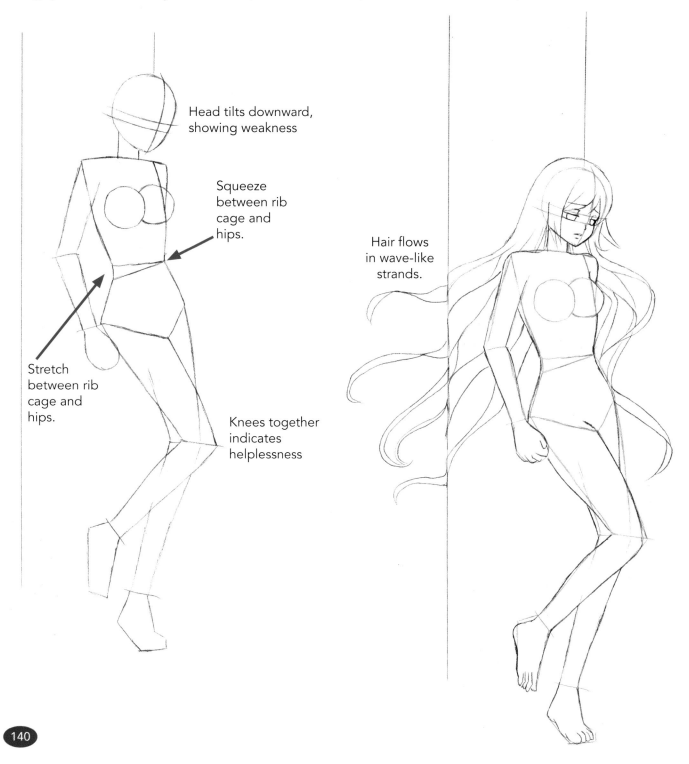

Head tilts downward, showing weakness

Squeeze between rib cage and hips.

Stretch between rib cage and hips.

Knees together indicates helplessness

Hair flows in wave-like strands.

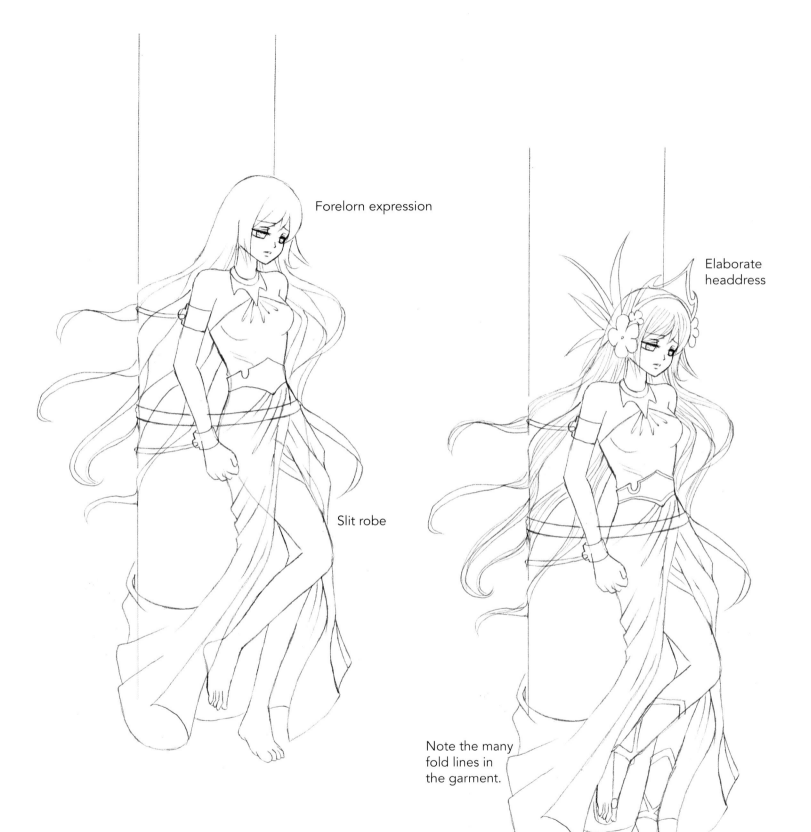

Forelorn expression

Slit robe

Elaborate
headdress

Note the many
fold lines in
the garment.

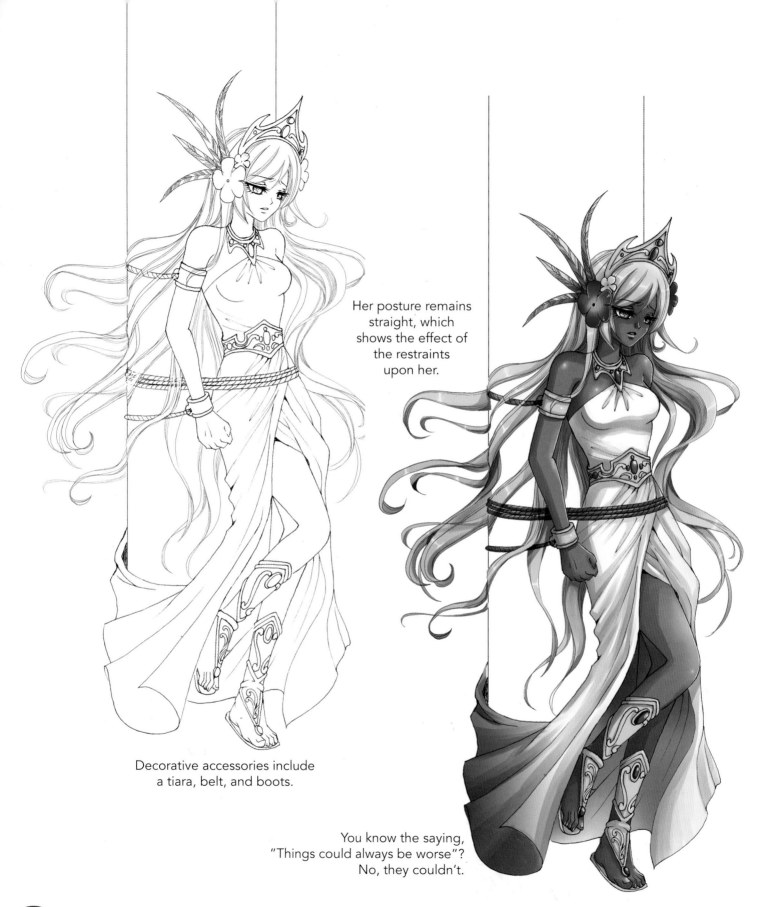

Her posture remains straight, which shows the effect of the restraints upon her.

Decorative accessories include a tiara, belt, and boots.

You know the saying, "Things could always be worse"? No, they couldn't.

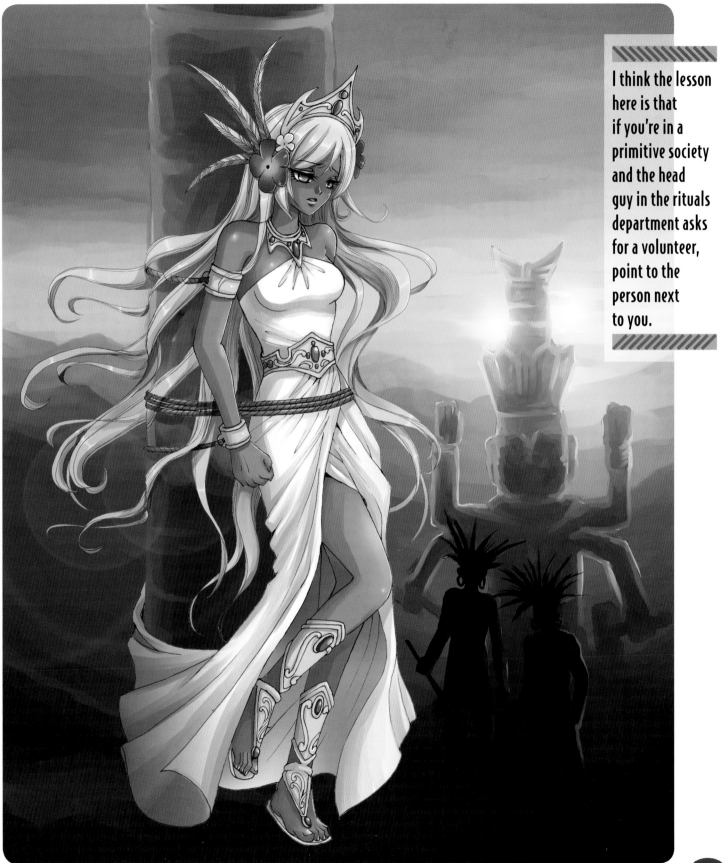

I think the lesson here is that if you're in a primitive society and the head guy in the rituals department asks for a volunteer, point to the person next to you.

Index